MW00608800

IMAGES
of America

THE CHILDREN'S
HOSPITAL
OF PHILADELPHIA

ON THE COVER: In 1921, this photograph was taken in the baby ward of The Children's Hospital of Philadelphia by Dr. Howard Carpenter, director of the first Department of Disease Prevention and an amateur photographer. Using his negatives and a lantern, Dr. Carpenter lectured to medical students, nursing students, and families with his slides.

IMAGES
of America

THE CHILDREN'S HOSPITAL OF PHILADELPHIA

Madeline Bell

ARCADIA
PUBLISHING

Copyright © 2015 by Madeline Bell
ISBN 978-1-4671-2284-9

Published by Arcadia Publishing
Charleston, South Carolina

Printed in the United States of America

Library of Congress Control Number: 2014945499

For all general information, please contact Arcadia Publishing:
Telephone 843-853-2070
Fax 843-853-0044
E-mail sales@arcadiapublishing.com
For customer service and orders:
Toll-Free 1-888-313-2665

Visit us on the Internet at www.arcadiapublishing.com

*To my colleagues for making The Children's Hospital
of Philadelphia a place where miracles happen and
for embodying the tagline "Hope Lives Here"*

CONTENTS

ACKNOWLEDGMENTS

I wish to acknowledge the Historical Medical Library of the College of Physicians of Philadelphia for archiving The Children's Hospital of Philadelphia images and for giving my collaborators and me easy access to their rich historical files, and I extend a special thank-you to librarian Beth Landers. Unless otherwise noted, all images appear courtesy of the College of Physicians.

Credit for preserving the hospital's archives goes to the late Shirley Bonnem, former vice president of the hospital. I thank Shirley for having the foresight to initiate and guide the archiving process and for serving as the hospital's historian until her passing in 2013. I am grateful to the Art Institute of Philadelphia, especially Christine Shanks, who spent hours of personal time supervising photography students for this project and ensuring the appropriate visual standards were met for each image.

Without my assistant, Beverly Callahan, I never would have made the deadline, and I thank her for bailing me out of numerous technical binds and for supporting me through this process. Additional thanks goes to Balu Athreya, MD, for sharing his historical materials with me and for filling in historical details, and to Mark Kocent, for hiking into the woods to photograph the former Country Branch archway (page 127) to help preserve it for future generations.

And, finally, I wish to send my heartfelt thanks to my collaborators, Alan Cohen, MD, former physician-in-chief and department chairman of pediatrics at The Children's Hospital of Philadelphia, for spending hours of his time at the College of Physicians library, elbows deep in archives, and for writing the introduction to chapter one; Louis Bell, MD, division chief of general pediatrics and my husband, for his tireless efforts in researching and cataloging the hospital's discoveries and innovations and for "owning" chapter three; Chris Feudtner, MD, for his expert support as a medical historian and for authoring the introduction to chapter two; and Stephanie Hogarth, chief marketing officer, for her support in proofreading and editing the copy and reviewing the images to ensure the book's worthiness.

INTRODUCTION

In celebration of its 160th anniversary, along with the opening of the largest building in its history, it is fitting to reflect on and honor the history of The Children's Hospital of Philadelphia and share the stories of its founders and successors, all of whom have made significant contributions toward shaping pediatric care in this country.

Many professionals have dedicated their careers to the hospital, including pediatricians, nurses, clinicians, administrators, trustees, volunteers, and others. Although some might have been forgotten by name or sight, these men and women have left a legacy as pioneers in the diseases of children. Their contributions have led to the hospital's recognition as one of the world leaders in pediatric care and discovery. The Children's Hospital of Philadelphia has seen the developers of new vaccines, concepts of disease prevention, innovative medical equipment, pediatric textbooks, and many medical training programs and innovations in pediatric care. The hospital started with a simple but clear message: to provide access to quality health care for poor children living in Philadelphia. From there, the founding fathers and those who followed realized that they had a responsibility to identify the causes of childhood diseases and discover treatments and cures.

From its inception, the founding physicians and nurses had a passion for teaching the next generation of health care providers. This mission to teach resonated throughout history with the first medical students and resident physicians of the 1850s to the founding of the nursing school in the late 19th century. Initially, the hospital was open to teaching all medical students, but in 1919, a formalized relationship with the University of Pennsylvania brought the teaching of pediatrics to its students. In 1930, a definitive affiliation was negotiated with the University of Pennsylvania whereby the professor of pediatrics at the university became physician-in-chief at the hospital, and pediatric faculty became professors of medicine at the medical school.

"Advice and medicines will be given free of charge," said the *Public Ledger*, announcing the opening of the hospital. Early donations to keep the hospital going included fuel, clothing, furniture, and food. By 1860, the managers had created the first permanent fund for operations of the hospital and its improvements. Fundraising began in earnest during the hospital's third year and continued with speaking engagements, theatricals, and concerts. Even in 1862, as the Civil War raged, a concert raised $630.71 for the hospital. Philanthropy has been critical to the growth and development of the hospital and has contributed to significant expansion, enabling world-class patient care and research. The story of the dedication and generosity of the many friends of the hospital, those who saw fit to contribute their time and money for the betterment of the hospital and the comfort of its patients and families, is told in the images and stories that follow.

So many interesting stories remained under wraps, hidden for years in the hospital's archives at the historic College of Physicians Medical Library. Perhaps these stories still resonate in the halls today in some small way. It has been the author's pleasure and privilege to sort through hundreds of historical photographs and documents dating back to the founding of the hospital and to arrange them into the story of its legacy. This book offers a glimpse into the lives The Children's Hospital of Philadelphia has touched and the many advancements it has made throughout its rich history.

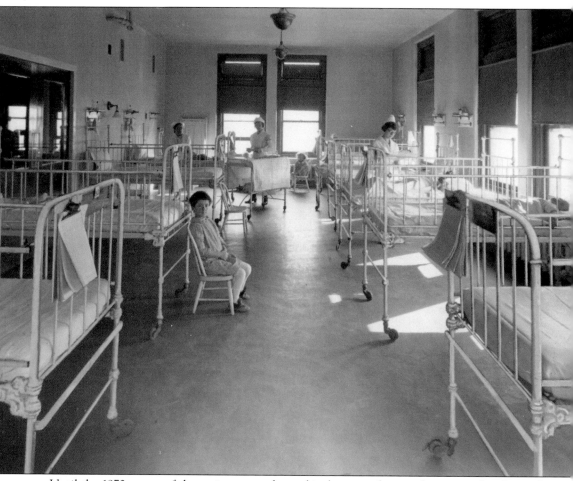

Until the 1970s, most of the patients were housed in large wards according to gender. Surgical and medical patients were kept in separate wards. The girls' surgical ward at the Bainbridge Street Hospital is depicted in this 1920 photograph.

One

A First of Its Kind
The Founding of a
Children's Hospital

The birth of the first children's hospital in North America took place in a city already well known for the nation's first voluntary hospital, founded by Benjamin Franklin and Dr. Thomas Bond; the nation's first medical school, founded by Drs. John Morgan and William Shippen Jr.; and the heroism of physician-patriots, such as Dr. Benjamin Rush, who signed the Declaration of Independence and later stayed in Philadelphia as others fled so that he could tend to those with Yellow Fever in the epidemic of 1793. Here, on November 23, 1855, Drs. Francis West Lewis, Thomas Hewson Bache, and R.A.F. Penrose placed the following notice in the *Public Ledger*:

> The Children's Hospital—located on Blight Street running from Pine to Lombard, below Broad, is now open for the reception of patients. Children suffering from Acute Diseases and Accidents will be received free of charge. A Dispensary, for sick children, is also attached to the Hospital and will be open at the same place every day (Sundays excepted) from 11 to 12 o'clock, when advice and medicines will be given free of charge.

Foretelling one of the basic principles of modern pediatrics, the board of managers sought "the alleviation of disease at that time when its evil effects can most easily be mitigated." However, they quickly recognized that parents were unwilling to "entrust their children to Hospital care and nursing during the acute stages of sickness," and the early medical staff found themselves mainly caring for children with chronic diseases, such as scrofula, gangrene, and wasting disorders. Therapeutic tools were initially limited to "good air, an even temperature, a well regulated diet and, above all, careful nursing." Infectious diseases like scarlatina and diphtheria were not a reason for admission but rather a feared contagion among the already weakened and chronically ill. To address these concerns, the hospital moved into a new structure with more open space in 1867 and, later, a larger and more secure isolation ward.

The new hospital on Twenty-second Street also brought innovations that are easily recognized today. In 1872, the medical staff added its first resident physician. Five years later, clinics for medical and surgical instruction were made accessible to students. Surgical outcomes were publicly reported. Winter and summer playrooms were built, a rooftop garden was established, and in 1911, the first social worker was hired. Another now familiar feature was that new programs, and a steadily increasing influx of acutely ill patients, quickly brought recognition that an even larger facility with "all modern improvements" was now necessary. By the beginning of the 20th century, fundraising for a new hospital was once again under way, and on September 1, 1916, all patients were transferred to the new hospital at Eighteenth and Bainbridge Streets, whereupon Chair of Pediatrics Dr. John Gittings set the tone for the future when he said, "Cohesion, coordination and cooperation are the order of the day. Accomplishment will know no limit other than that of the exchequer."

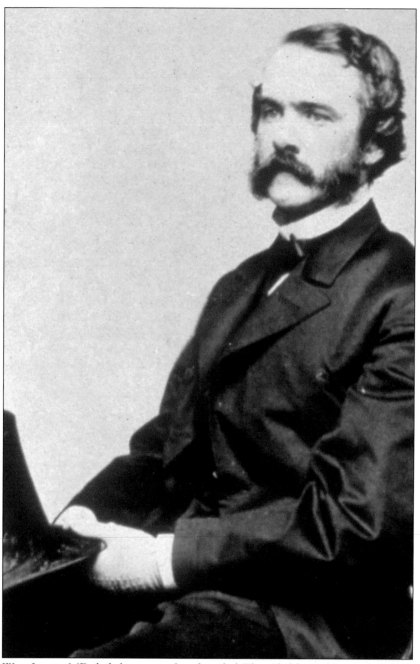

Francis West Lewis, MD, led the group that founded The Children's Hospital of Philadelphia in 1855. After graduating from the University of Pennsylvania School of Medicine and training at Pennsylvania Hospital, he studied in Dublin, Paris, and London. It was in London that he developed a deep interest in caring for children. Both inspired by the opening of the Hospital for Sick Children at Great Ormond Street in London and disturbed by the high mortality rate among infants and children, he returned to Philadelphia to open the first children's hospital in the United States with two other collaborators. His family fortune allowed him to devote his entire professional career to its service, until his death in 1902.

R.A.F. Penrose, MD, joined Dr. Francis West Lewis in the founding of The Children's Hospital of Philadelphia. Dr. Penrose trained at Pennsylvania Hospital, where he became professor of obstetrics and diseases of women and children at the University of Pennsylvania. Having the gifts of both an orator and an actor, Penrose was known as a great lecturer who staged a drama of birth and all its emergencies with a realism that thrilled the inexperienced boys in his lecture room and clothed his precepts with unforgettable poignancy.

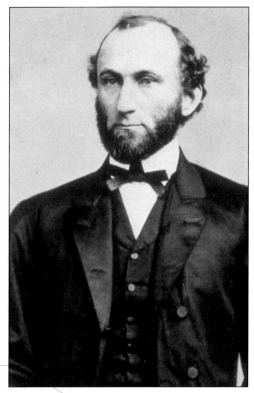

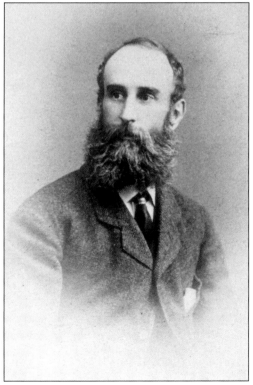

Thomas Hewson Bache, MD, was a collaborator in the founding of The Children's Hospital of Philadelphia. Dr. Bache was a descendant of Benjamin Franklin and a surgeon during the Civil War. He served on the hospital's board of managers for many years and remained an emeritus manager until his death at age 86 in 1912. At the time of his death, he was eulogized as "the descendant of a distinguished family" in the board of managers report, which also stated, "His services as a surgeon in the Civil War were most notable and he was a gentleman of the highest type and probity." Many of the early tracheotomies were recorded under his initials, THB.

11

On November 23, 1855, the first hospital was opened in a small three-story brick building at 408 South Blight Street (now called Watt Street), a narrow thoroughfare near Broad and Pine Streets. The original building began with only 12 beds, and within three months, the hospital was fully occupied, with patients overflowing into the corridors. Within two years, the house next door was incorporated, increasing the number of beds to 20.

By 1865, the hospital had outgrown its initial modest building and accepted an offer to use the property recently occupied by the Civil War Officer's Hospital, known as Camac's Woods, on the corner of Eleventh Street and Columbia Avenue in Philadelphia. The hospital overflowed patients to Camac's Woods, but brief operations there showed that the cost of renovating and heating the 70-bed building would be beyond the resources of the hospital. At the time, the managers determined that Camac's Woods was too far from the poor children of Philadelphia. As an alternative, the managers planned a new hospital, which was erected in 1867 and designed to fulfill the most modern hospital requirements. The cost was $25,000 for 35 hospital beds. Over the years, bed capacity in this "free hospital for all colors and creeds" was continually expanded. By 1894, inpatient units included separate surgical wards for boys and girls, a medical ward, a baby ward, a convalescent ward, eye and ear wards, a croup ward, and two quarantine wards.

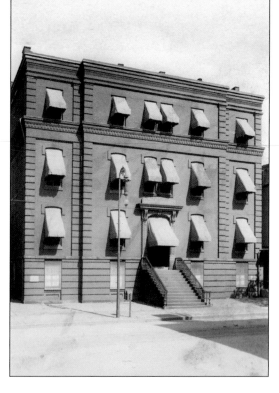

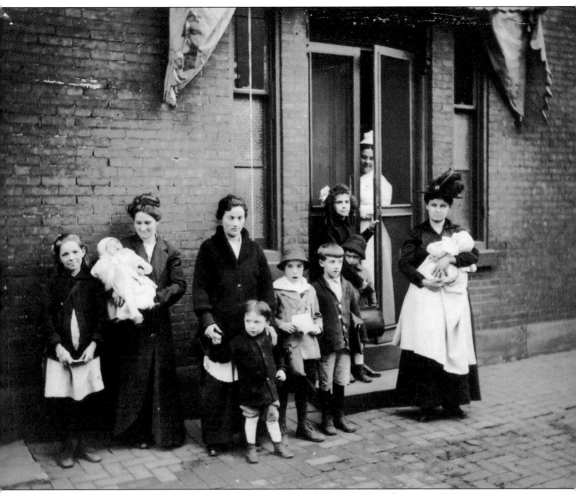

In the 1890s, mothers and children lined up in front of the "outdoor dispensary" to receive care and medications free of charge at the Twenty-second and Locust Streets location. By 1874, there were at least six physicians working in the outdoor dispensaries. This service became expensive, and by 1879, there were grumblings about the abuse of this charity, leading the board of managers to consider the determination of proof of need on the part of patients. It was not until 1927, however, that the dispensary instituted a nominal charge to patients.

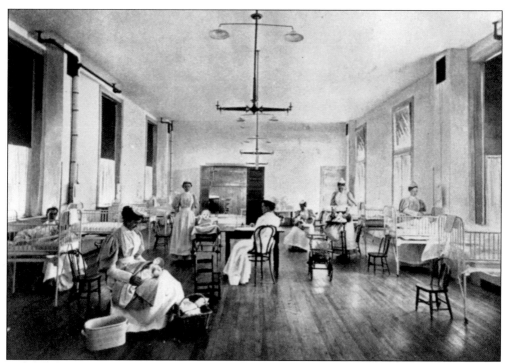

The 1896 annual report featured one of the first images of the hospital's baby ward in the building at Twenty-second and Locust Streets.

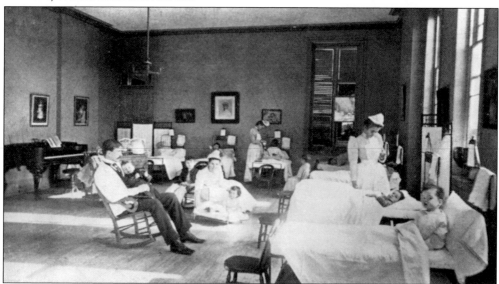

Among one of the best images from the hospital collection is this 1892 photograph of the girls' surgical ward, where nurses and a resident physician are comforting a patient. As with other early photographs, a piano and toys can be seen in the background. That same year, the Philadelphia Department of Health closed the croup ward because of a diphtheria outbreak; 12 children and a resident died of hospital-acquired diphtheria. The Department of Health subsequently halted surgical admissions to the hospital, resulting in the deaths of children in the community who were waiting for life-saving surgery.

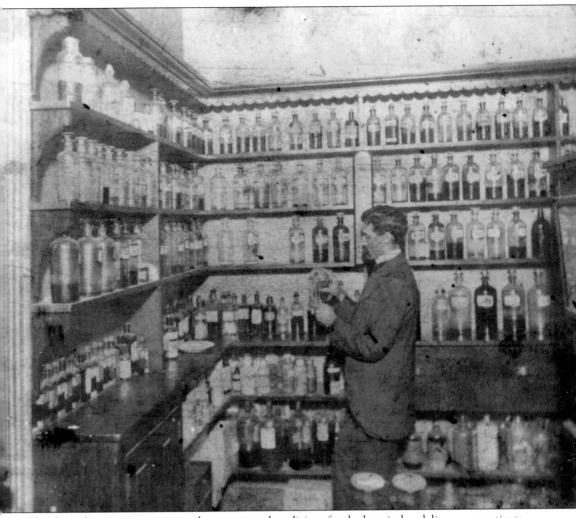

Resident physicians were required to compound medicines for the hospital and dispensary patients. This 1873 photograph was taken in what was known as the Drug Room.

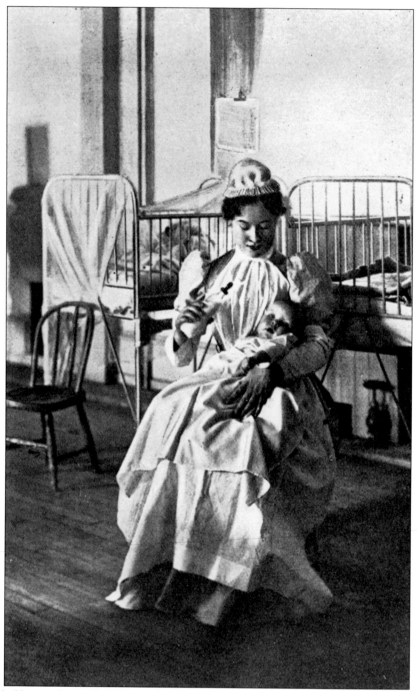

A nurse holds an infant in the baby ward in 1896. The first hospital administrator, or superintendent, as she was called, was appointed in 1891. A graduate from the Nursing School of Philadelphia General Hospital, her duties included supervision of medical matters, as well as housekeeping and economic duties. A long tradition of nurses serving as superintendent continued until just before World War I, when the first physician was appointed. With the advent of the war, nurses continued to serve in this role until the administrative structure changed in the mid-20th century.

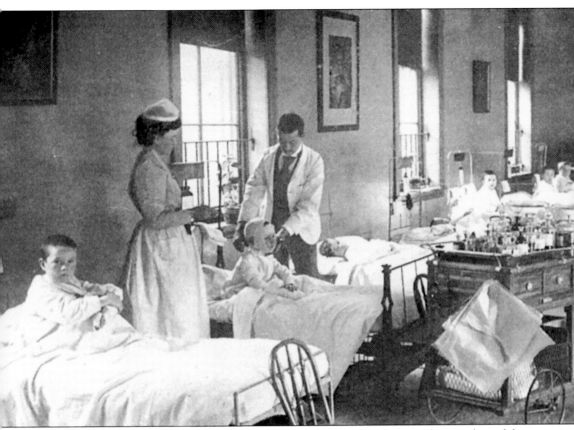

The Department of Aural Surgery was created 10 years before this photograph was taken of the boys' surgical ward in 1891. Mastoidectomies became popularized in 1873, which significantly increased the number of surgical admissions to the hospital.

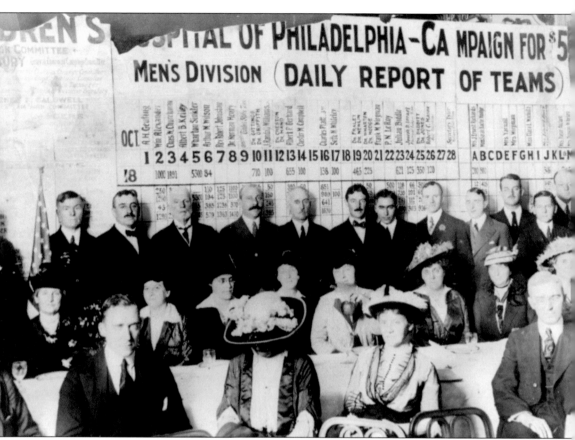

In 1915, a fundraising luncheon was held to solicit donations for a new hospital. In the background is a large board tallying donations from individuals attending the event.

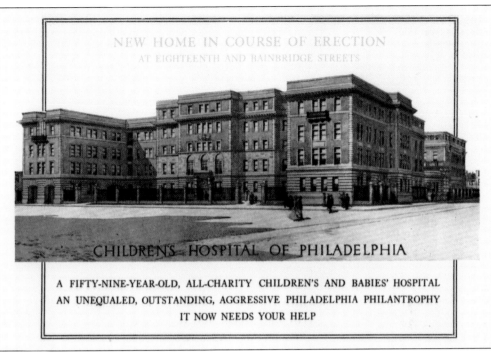

NEW HOME IN COURSE OF ERECTION
AT EIGHTEENTH AND BAINBRIDGE STREETS

CHILDREN'S HOSPITAL OF PHILADELPHIA

A FIFTY-NINE-YEAR-OLD, ALL-CHARITY CHILDREN'S AND BABIES' HOSPITAL
AN UNEQUALED, OUTSTANDING, AGGRESSIVE PHILADELPHIA PHILANTROPHY
IT NOW NEEDS YOUR HELP

Significant fundraising was required to erect the third location of The Children's Hospital of Philadelphia. Using posters and advertisements, the campaign of 1915 was designed to raise $500,000 in 10 days for the proposed Bainbridge Street building.

The Board of Managers
of the
Children's Hospital of Philadelphia
requests the honour of your presence
at the laying of the cornerstone of the
New Hospital Buildings
Eighteenth and Bainbridge Streets
on the afternoon of Wednesday, the twenty-second of October
at half after three o'clock

The preliminary exercises
will be held in
Holy Trinity Baptist Church
1820 Bainbridge Street

Seen here is the invitation to the laying of the cornerstone for the new hospital site at Eighteenth and Bainbridge Streets in 1913.

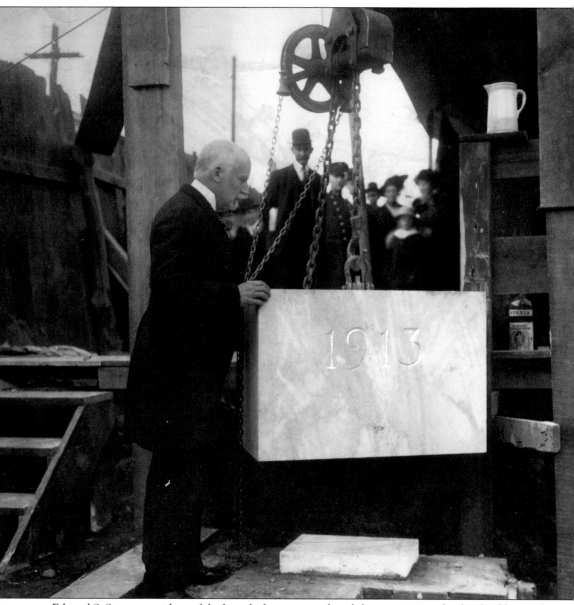

Edward S. Sayres, president of the board of managers, placed the cornerstone for the third hospital during the ceremony held in 1913. Mrs. Sayres kept an extensive scrapbook of hospital events, including newspaper coverage of this occasion. The event was widely attended by the medical community and notable Philadelphians.

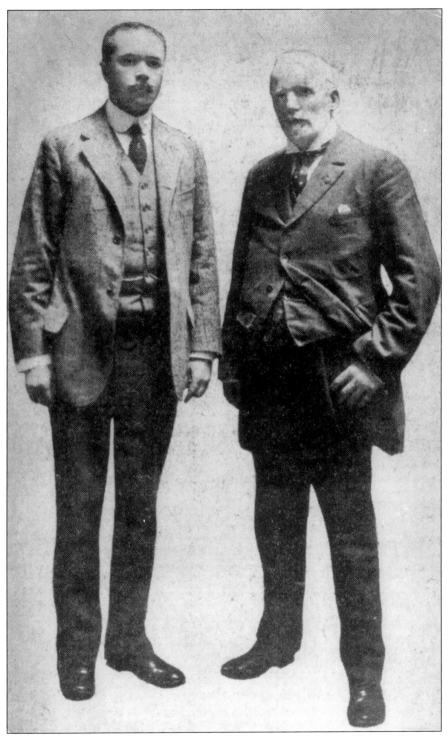

The eighth hospital president, Edward S. Sayres (right), who served from 1912 to 1923, poses with Benjamin Rush, who subsequently served as president from 1924 to 1930. As president of the hospital, Edward Sayres oversaw the planning and occupation of the new Bainbridge Street building.

In 1916, the third building was opened at Eighteenth and Bainbridge Streets with 70 beds, and by the end of the first year, accommodations were crowded with 77 patients. A new unit was erected in 1922, increasing the bed capacity to 95, and five "temporary baskets," added a year later, rounded out the number to 100. A wing to accommodate operating rooms, along with 17 more beds, was added in 1928.

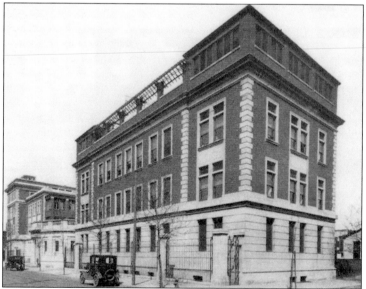

Additional fundraising campaigns were launched to fund expansion over the next five decades. Despite the stock market crash and ensuing depression, newspaper appeals were answered by many Philadelphians, including Al Capone. From his cell at the Holmesburg Prison, Capone authorized his attorney to send the hospital a check for $1,500.

MOVING DAY FOR CHILDREN'S HOSPITAL

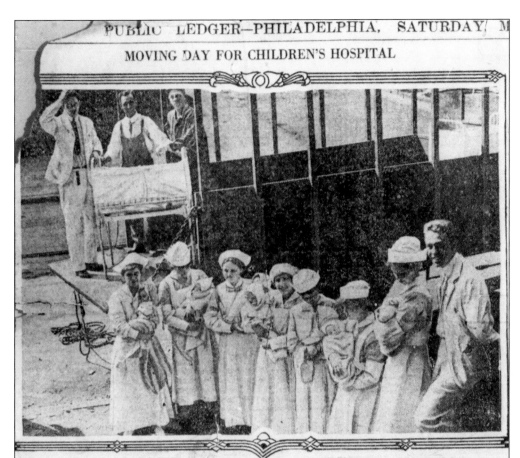

The man standing on the truck and scratching his head is Dr. N. A. Christensen, chief resident of the Children's Hospital. He is trying to figure out how to put 35 babies into cribs in the truck and leave room for the nurses to ride. The photograph was taken yesterday afternoon, when the hospital moved the last group of babies from its old home, on Twenty-second street below Walnut, to a new structure, the last unit of which was completed this week, at Eighteenth and Bainbridge streets. The cribs from the hospital were loaded into a big truck furnished by the quartermaster's department of the United States Marine Corps and the babies were placed carefully in the cribs. Then sheets were pinned over the cribs to keep out the sun. No ill effects were caused by the transportation of the little patients. Nurses and doctors lugged cribs, tables, trays of bottles, chests of clothes and other hospital paraphernalia out and down the steps all the afternoon, while men loaded them into another truck and took them to the new building. The old home of the hospital, which has been occupied for more than forty years by the institution, is now for sale. It will, however, be used for a time as a home for some of the nurses. The new building, which was started three years ago, has a capacity of 70 patients. Edward S. Sayres, president of the board of managers, said that it was planned to erect an addition soon that would double this capacity

In 1916, on moving day to the hospital's new location, chief resident Dr. Christensen (left) stands on the back of the truck trying to figure out how to transport 35 babies in cribs, along with the nurses, in a truck furnished by the quartermaster's department of the US Marine Corps. Sheets were pinned over the cribs to protect the babies from the sun. According to the annual report from that year, "No ill effects were caused by the transportation of the little patients."

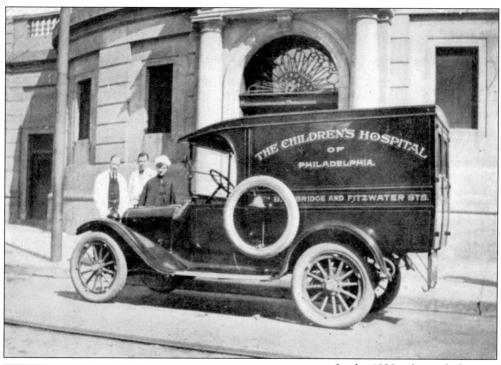

In the 1920s, this ambulance was used to transport patients to the Bainbridge Street hospital. It is pictured here with the first transport team, which included a nurse, a physician, and an attendant.

By 1921, when this photograph was taken, the hospital had once again been fully staffed after losing 50 percent of its active medical staff to government service during World War I.

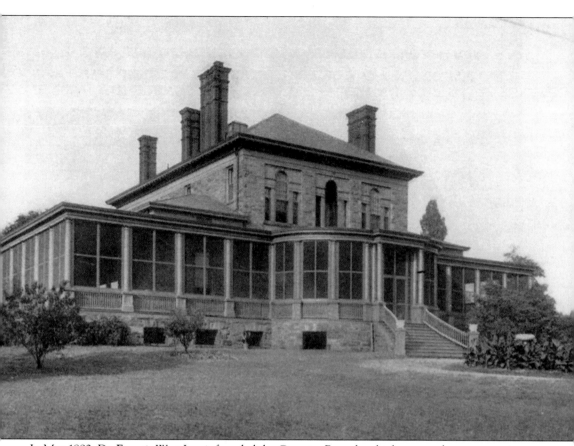

In May 1892, Dr. Francis West Lewis founded the Country Branch, which operated as an extension of the hospital. Over the next 30 years, the Country Branch closed several times due to lack of funds. Records show that, although closed for three years, the Country Branch reopened in 1925 due to successful fundraising. The Country Branch was situated on the corner of Parkside and Bryn Mawr Avenues, near Fairmount Park. It was surrounded by a beautiful eight-acre tract of land. According to the 1892 annual report, it was considered a "great advantage to our chronic and bed ridden—many of whom are compelled to lie for weary months of suffering, breathing the heavy and depressing air of the city—by a change to the country with its open sunlight and more cheerful environment." The report went on to explain, "How often a few days of removal from the hot closeness and impure atmosphere of the town to the pure air and open sunlight, and the invigorating influence are able to command, at a point so near the city, will change the very expression of a child-patient and react most favorable on its whole physical and moral being—this often in cases where all hope of final recovery may have been abandoned."

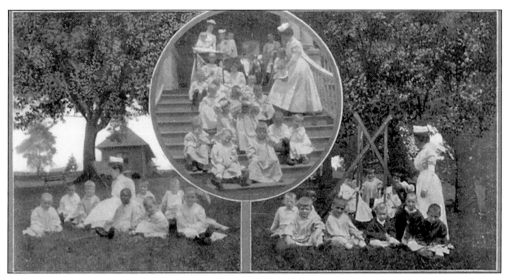

In 1900, a postcard about the Country Branch was issued for raising awareness, as well as to promote fundraising. After the first few years of operation, a resident physician began spending summers at the branch to support the medical needs of the patients. In the 1892 annual report, the resident physician stated, "If those who gave time, energy and money to the support of the Country Branch had been able to watch from day to day how the wan and hallow cheek became round and rosy; the listless and spiritless disposition became first quickened and finally alert for fun and frolic and how, in many cases, under the stimulus of encouragement and genial surroundings, the ideas for personal cleanliness, attention to attire, respect for the rights of other, etc., took root and grew, surely all would have felt doubly repaid."

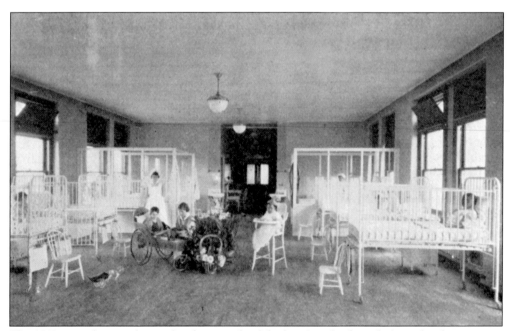

The 1919 annual report featured a photograph of the boys' medical ward. As with other pictures from this time, patients are shown involved in play activities during their inpatient stay.

This photograph of the operating room at the Locust Street building was taken in 1899. The surgical department was separated from the medical department when John Ashhurst Jr. joined the staff in 1870. At age 24, after years of experience in the Civil War, he developed an interest in what is now known as orthopedic surgery. He grew famous for his surgeries on "white swelling" of the bones and joints. In 1948, the surgical department became part of the Department of Surgery at the University of Pennsylvania.

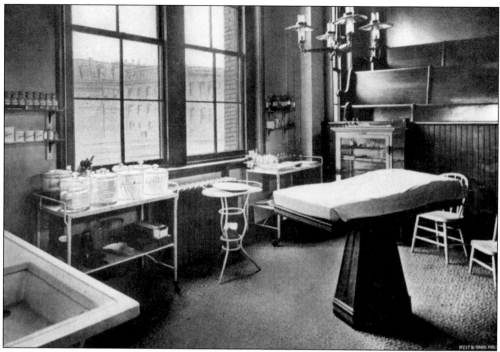

Another view of the operating room before the move to Bainbridge Street can be seen in this photograph, which was taken at the Locust Street location in 1915.

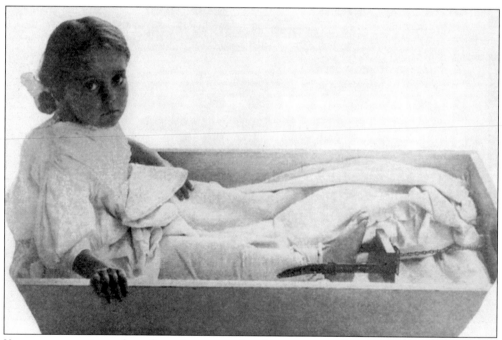

Young postoperative orthopedic patients were placed in traction and immobilized in small wooden bins, as is seen in this 1915 photograph.

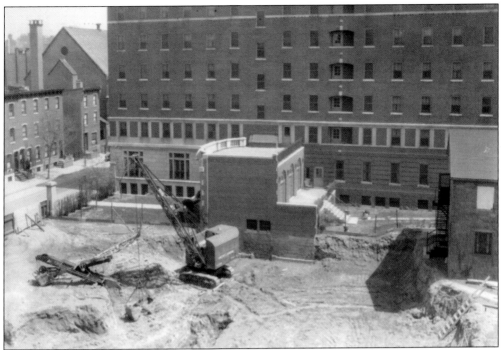

The Catherwood building was under construction in this 1927 photograph. The new building would soon house operating rooms, expanded inpatient beds, and support space.

Pictured here is the modern operating room at the Bainbridge Street hospital. Turner Construction took this photograph in 1928, after the Catherwood addition was built. Nearly 90 years later, Turner was once again commissioned to erect the newest building on the hospital's campus.

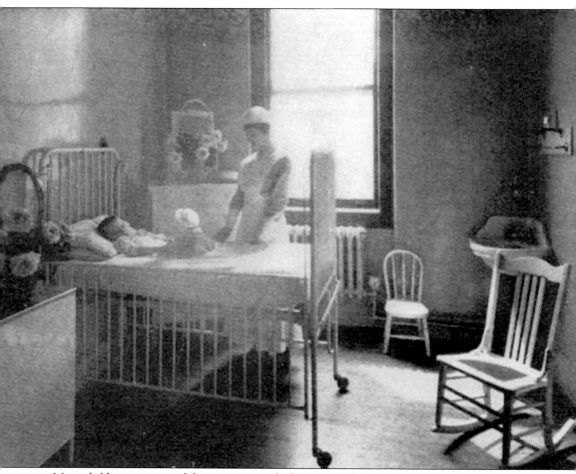

Most children were cared for in open wards, but some of the rooms were endowed by donors, allowing a few children to have private rooms.

Permanent Free Beds

MEMORIAL I. V. WILLIAMSON.	IN MEMORY OF F. MORTIMER LEWIS. By his daughters.
MEMORIAL I. V. WILLIAMSON.	IN MEMORY OF ANNA MARIA DUNDAS
MEMORIAL I. V. WILLIAMSON.	IN MEMORY OF JAMES DUNDAS.
MEMORIAL I. V. WILLIAMSON.	IN MEMORY OF ROBERT WADE.
MEMORIAL I. V. WILLIAMSON.	IN MEMORY OF THOMAS H. POWERS.
MEMORIAL I. V. WILLIAMSON.	IN MEMORY OF ANNA M. POWERS.
IN MEMORY OF SARAH C. BALDWIN.	IN MEMORY OF CLARA MELLON.
IN MEMORY OF SARAH C. BALDWIN.	IN MEMORY OF COUNT GOFFREDO GALLI.

Friends of the hospital endowed "free beds" for the care of inpatients, which became a common way to memorialize physicians, nurses, and administrative leaders who had dedicated their careers to the hospital.

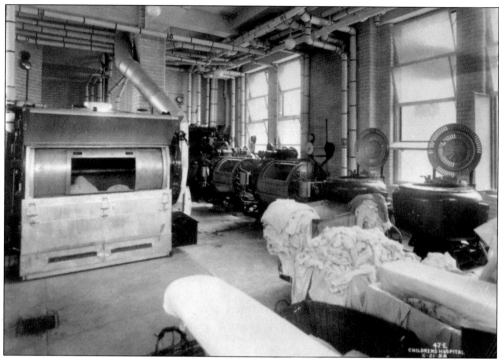

A modern laundry was added to the Catherwood building, allowing for sterilization of patient linens and napkins.

As part of a recent addition in 1932, Turner Construction photographed the newly constructed modern milk laboratory of Catherwood.

The late Sarah Emlen Ingersoll left a bequest to the hospital to open the Ingersoll Nursing School in 1895 with a nursing superintendent, a surgical supervisor, a medical supervisor, and seven student nurses. As stated in the annual report a few years later, "The average nurse cannot be expected to be a good manager of little patients unless she has had some opportunities to learn how. These opportunities are being constantly increased at Children's Hospital." By 1906, there were 286 applicants vying for 12 positions. The school served the hospital until it closed in 1945.

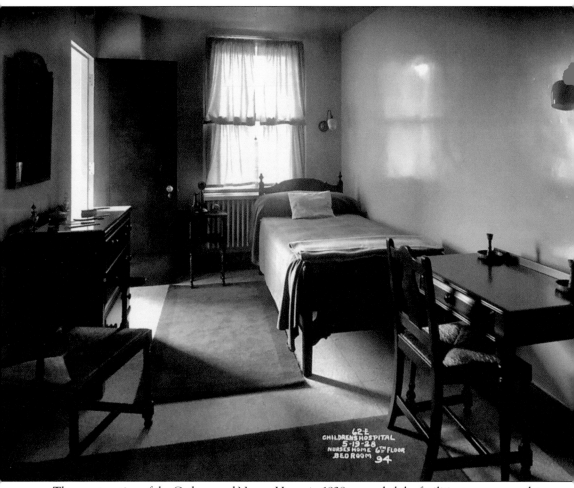

The construction of the Catherwood Nurses Home in 1928 expanded the facilities to accommodate 117 nursing students. A typical student nurse's dorm room is pictured here.

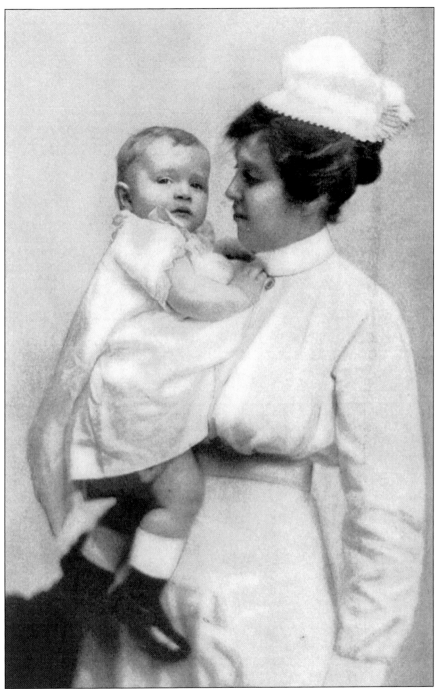

A hospital staff nurse holds a patient in this 1916 photograph. That year, the annual report stated, "The Training School for Nurses is continuing its good work, and our graduate nurses, as heretofore, are much sought after. The principal of the Training School for Nursing, Head Medical and Head Surgical Nurses, pupil nurses and the other employees have given great care and attention to all work under their care and at the time of the moving of the old hospital to the new were unremitting in their desire to help one another in that arduous undertaking."

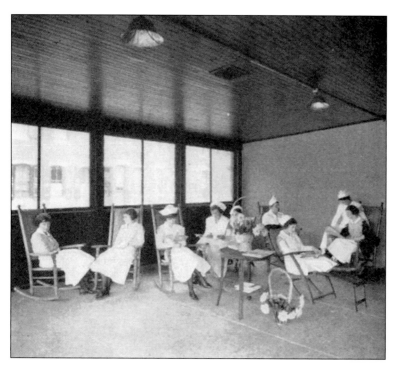

What little time nursing students had away from the bedside they spent studying in common areas at the nurses' home, as seen in this 1923 photograph of nurses on the porch. Nursing students were given two weeks of vacation each year, but because nursing students were a critical component of staffing, approval for vacations was subject to the needs of the hospital.

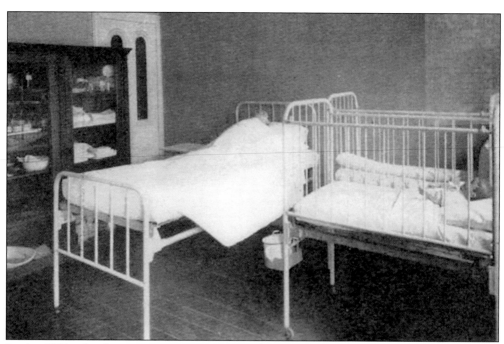

In the 1920s, the demonstration room was used to teach clinical skills to nursing students, similar to the modern-day simulation centers now found at hospitals, as well as medical and nursing schools.

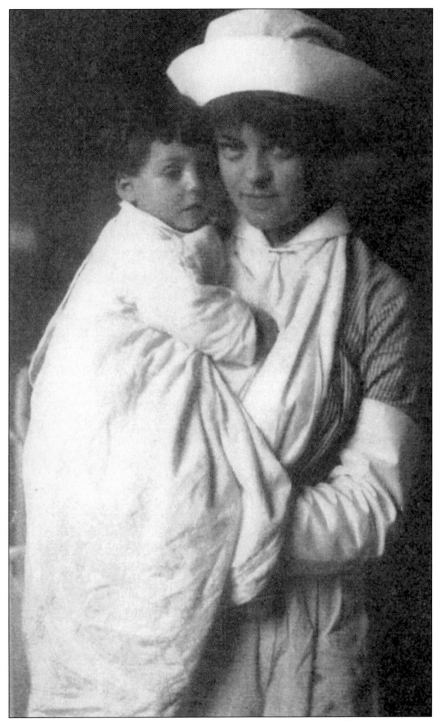

Next to this photograph of a nursing student with a patient found in the 1915 Annual Report was the following note: "The Training School for Nurses is doing its customary good work and our nurses are not excelled by any. They all entered into the Campaign for the raising of funds with the true and loyal ability, and by their efforts added much to its success."

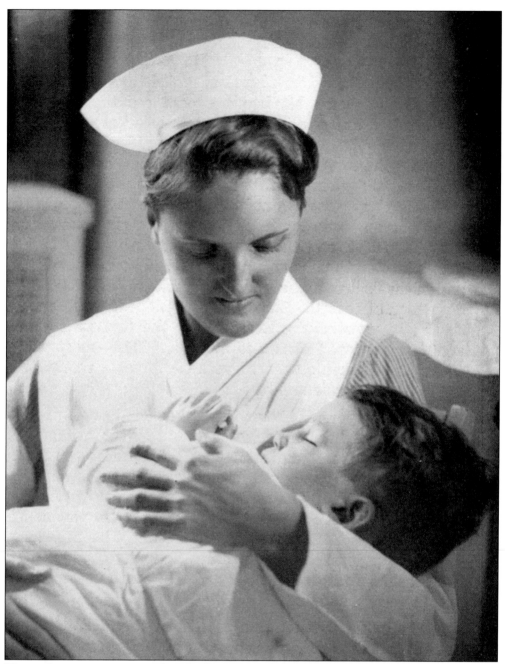

This student nurse was pictured on the front cover of *The History of Children's Hospital*, written by Arthur Lea in 1933. This book provides insight into the founding and expansion of the hospital in the early years and highlights the contributions of physicians and staff who helped to shape its history.

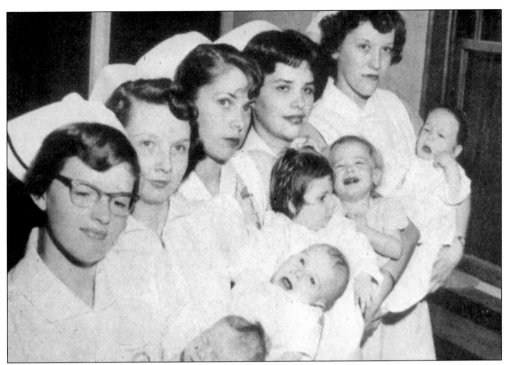

Here, five nurses pose with babies from the surgical ward in 1952. Noted on the back of the photograph is "esophageal atresia." Presumably, one of the babies in this photograph received surgery for a malformation of the esophagus. By 1952, the Ingersoll Nursing School had closed, but the hospital continued training nurses from a variety of surrounding schools. The long tradition of training nursing students in the care of children continues today.

Admission to the Ingersoll Nursing School required a letter from a clergyman attesting to the good moral character and qualifications required for undertaking professional work. Applicants admitted to the school had to be between the ages of 18 and 35 and had to bring at least $19 dollars to fund their books in the preliminary year. In 1923, this proud group of nurses lines up in front of the nursing school for their graduation day.

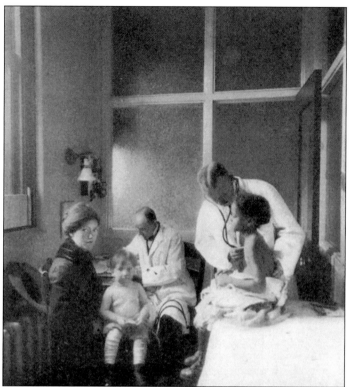

Outpatient services have remained an important part of providing care to the community, from the hospital's inception to the present day. In this photograph, patients are being examined in the medical dispensary, the outpatient area of the hospital. It was not until 1927 that the dispensary instituted a nominal charge to patients.

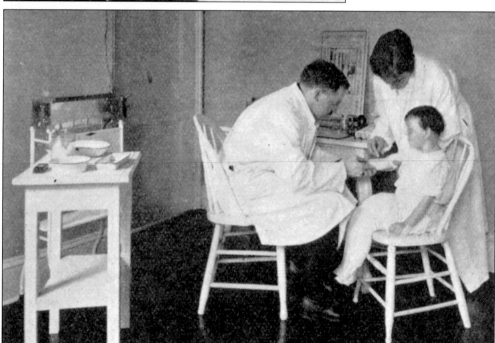

A physician examines a patient in the diphtheria clinic in 1925. Until the advent of a vaccine in the 1920s, diphtheria was among the leading causes of death in children. It was first isolated as a bacteria in the 1880s, and the hospital developed the clinic shortly after that time.

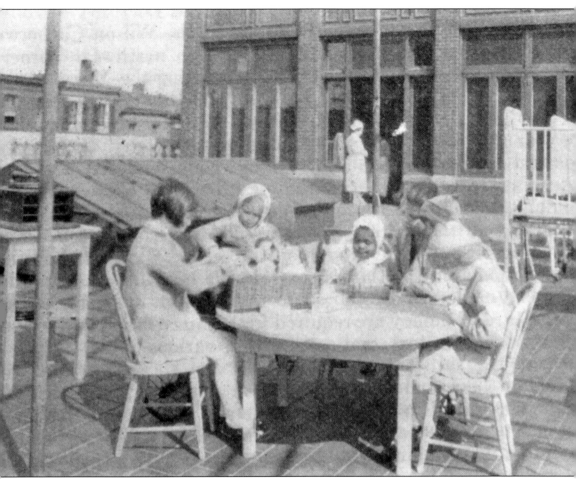

The rooftop garden served as an important component of the patient care experience. Here, children are engaged in occupational therapy on the rooftop garden in 1924.

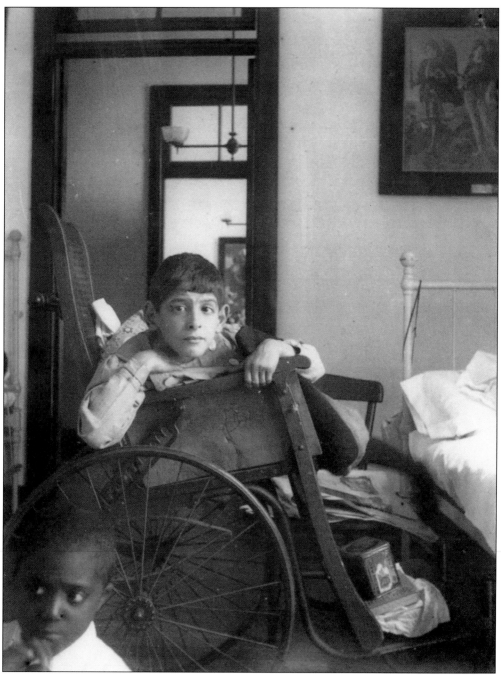

These boys were patients of the medical ward at the Bainbridge Street hospital in 1930. That year, the annual report stated that the hospital was "filled to capacity and turning away too many children."

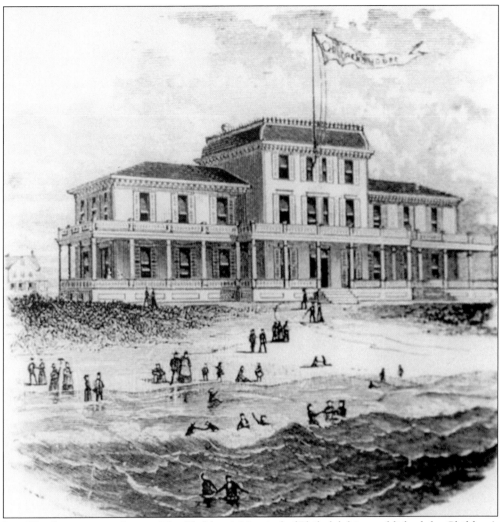

In 1872, physicians working at The Children's Hospital of Philadelphia established the Children's Seashore House, which officially became part of the hospital in July 1998. The beachfront hospital was founded on the belief of the restorative nature of fresh seaside air and its ability to improve the health of children. During its first year of operation, the Children's Seashore House was located in a converted summer cottage on the corner of South Carolina and Pacific Avenues in Atlantic City. In the summer of 1873, the hospital was moved to Ohio Avenue, where 55 patients were accepted. The original notion of convalescence was dismissed as an antiquated practice, replaced by modern concepts of rehabilitation. The Children's Seashore House became the first pediatric rehabilitation hospital in the country.

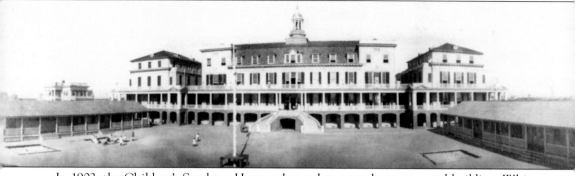

In 1902, the Children's Seashore House relocated to a newly constructed building, Whitney Hall, located on the beach block between Richmond and Annapolis Avenues in Atlantic City. Initially, the Children's Seashore House only took patients in the summer months, then began to operate year-round in 1909. Through the years, it maintained a close working relationship with The Children's Hospital of Philadelphia, until the two hospitals merged in 1998.

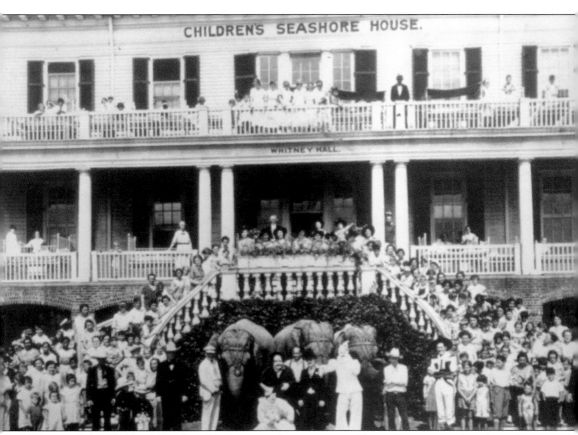

Patients at the Children's Seashore House were often entertained by performers traveling through Atlantic City. In 1915, a circus with elephants and clowns performed for the children.

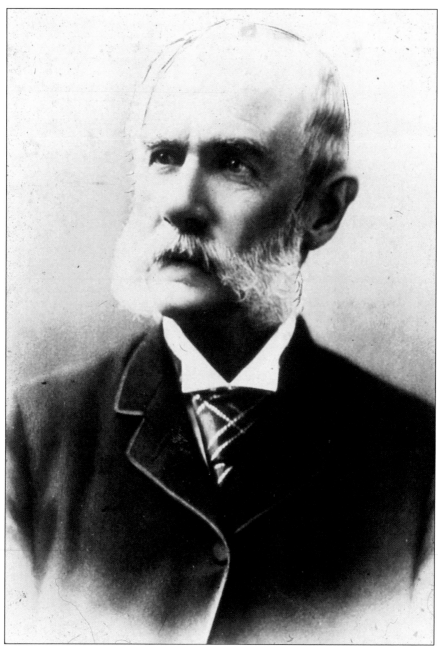

The 1902 annual report stated, "On the 3rd day of March, 1902, Dr. Francis West Lewis died after a brief illness and through his death the Hospital sustained an irretrievable loss. He was practically the founder of the Hospital and has been President of the Board of Managers for many years. The little sufferers on the wards knew what manner of man he was, and when his kindly face appeared in the doorway, cries of 'Dr. Lewis' went up from a dozen or more childish throats in heartfelt welcome . . . His generosity, his constant thought for and care of others, perhaps, above all, his modesty and shrinking from any publicity for his deeds of mercy, will live in our hearts; and for those helpless ones to whom this Hospital ministers and for whom it stands the best memorial that can be made of him."

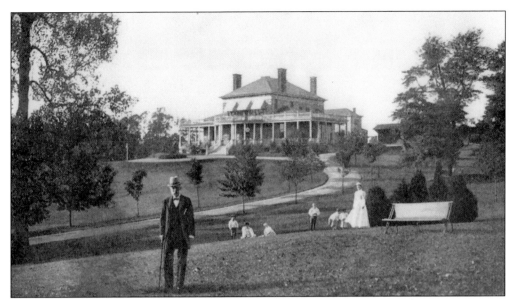

Dr. Lewis is pictured here walking on the lawn in front of the Country Branch in 1900, just two years before his death. The 1902 annual report noted, "Realizing the great interest Dr. Lewis took in the welfare of the Country Branch, efforts were made shortly after his death to secure special contributions to enable the Board to open it for the summer of 1902, which were very successful and realized the sum of $3,932.62."

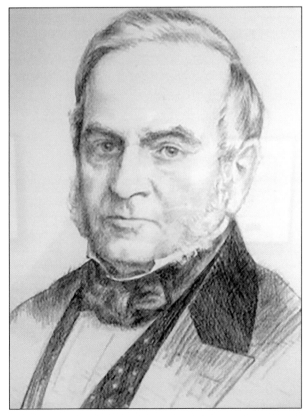

Mordecai D. Lewis was the first president of the board of managers, a role in which he also served as the hospital's president. Lewis, the wealthy merchant father of founder Dr. Francis West Lewis, served as the president of the hospital from its founding in 1855 until 1861. He was the first person to leave a bequest to the hospital.

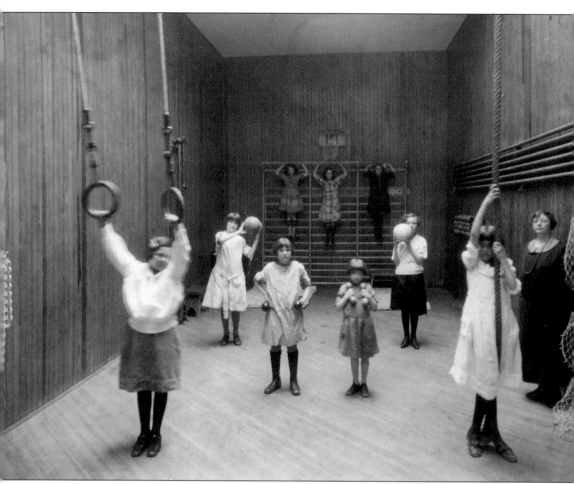

Calisthenics class was a program within the Department of Disease Prevention. This photograph was taken by Dr. Howard Carpenter in 1918.

Two

WHAT'S OLD
IS NEW AGAIN
THE ORIGINS OF MODERN PEDIATRICS

Medical specialties, including pediatrics, have a history defined by the discoveries and contributions of great people and by broader social and cultural influences. Similarly, hospitals are more than just buildings; they are complex, dynamic organizations, reflecting and shaping the age in which they exist.

While children have, since time immemorial, taken ill, suffered injury, or been born with various conditions, it was not until the 1860s, with the pioneering efforts of Abraham Jacobi, that pediatrics as a specialty started to take shape. At this time, one out of every three infants died before celebrating a first birthday. Today, due to improvements in infant feeding, the development of antibiotics in the 1930s and vaccines thereafter, and remarkable developments in obstetrical and neonatal care, infant mortality has been reduced to 1 in 166—an extraordinary achievement set against a backdrop of public health advances that improved the safety of drinking water in the 19th century, introduced injury prevention in the 20th century, and provided greater access to care regardless of socioeconomic status.

Predating the rise of pediatrics as a specialty, however, was the growth of hospitals dedicated exclusively to children. Starting in Paris around 1800 and followed by London's Great Ormond Street Hospital for Sick Children in 1852, the first US pediatric hospital was founded in Philadelphia in 1855. From the mid-19th century onward, hospitals were reshaped by antisepsis, advancements in anesthesia and surgical care, the rise of laboratory and radiographic investigations, and significant developments in science and technology. From the initial focus on the treatment of orthopedic deformities and promotion of convalescence from long-duration illnesses through the advent of modern pediatric surgery, neonatal intensive care, pediatric oncology, and the rise of child life as a distinct specialty, the focus of children's hospitals has remained the same—helping and healing sick children.

Images in this chapter depict the roots of modern pediatrics, including disease prevention, play therapy, art therapy, music therapy, and outdoor excursions, all with the focus of normalizing the hospital experience for children.

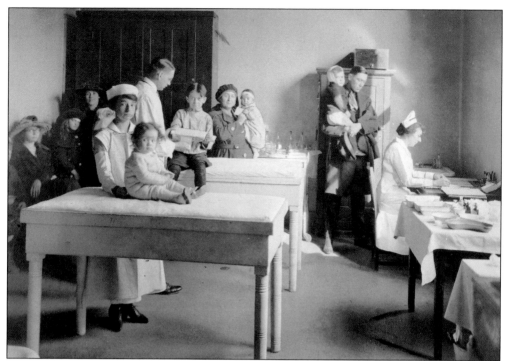

Mothers, patients, and staff gather together in a single room that operated as the surgical dispensary in 1921.

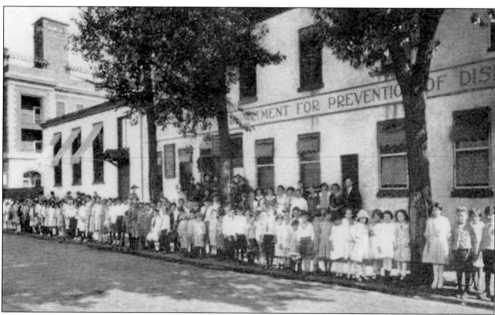

Patients and families line up in front of the Department of Disease Prevention for the annual picnic day in 1923. Howard Childs Carpenter, MD, initiated the concern for the social side of pediatrics when he established the Department of Disease Prevention in 1914. Dr. Carpenter had an interest in photography and captured many of the department's activities. The department closed in 1939, as prevention had become de-emphasized with a focus on inpatient acute treatment.

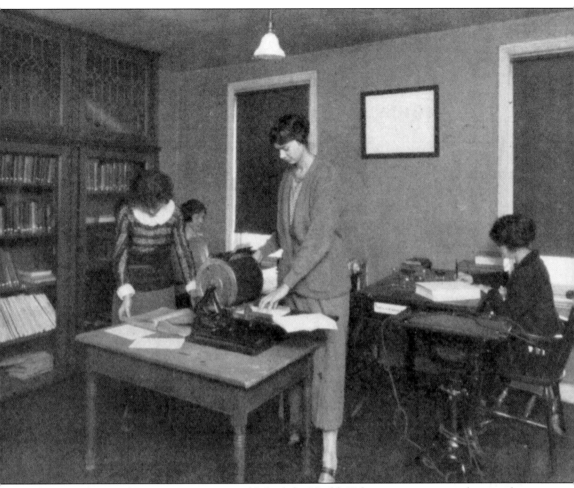

The Department of Disease Prevention published the *Health Help* magazine, as seen here in the production room in 1923. In a public address, founder of the department Dr. Howard Carpenter said, "The ideal children's hospital would minister not only to the illness of infants and children but to the entire child, his physical and mental health and development and also to prophylaxis to disease."

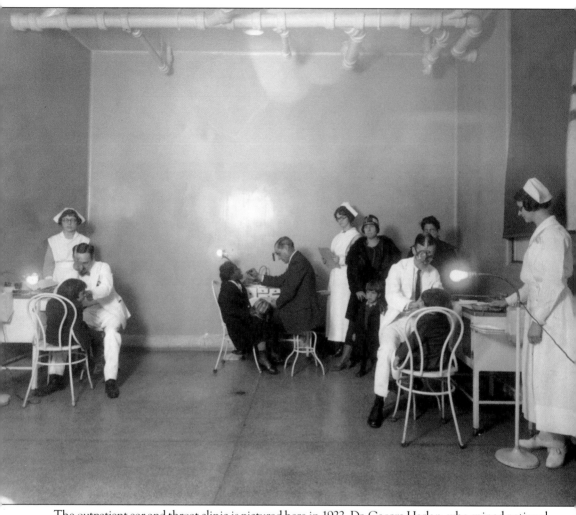

The outpatient ear and throat clinic is pictured here in 1922. Dr. George Harlan, who gained national acclaim as a pediatric eye surgeon, started the dispensary for the eyes and ears in 1872.

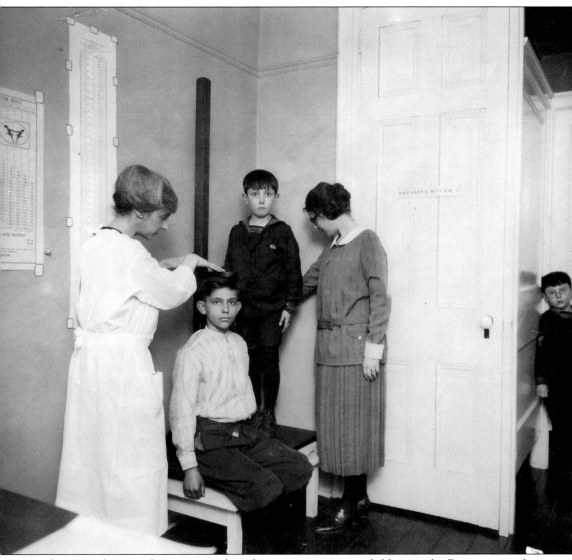

In this 1921 photograph, nurses weigh and measure outpatient children at the Department of Disease Prevention. That year, the annual report referenced the following records from the department: "1,645 consultories, 2,996 interviews, 4,132 telephone calls in and out and 4,236 patient letters written."

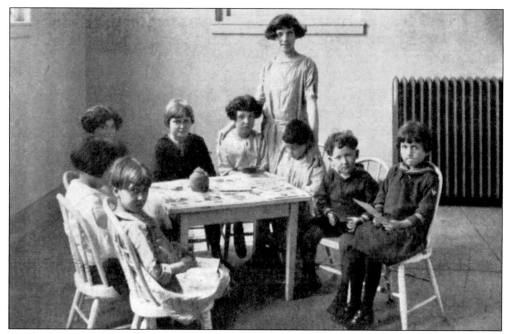

Teachers supported the education of children's health maintenance for local Philadelphia children enrolled in the disease prevention program. Many of the classes were taught to immigrant children and their parents.

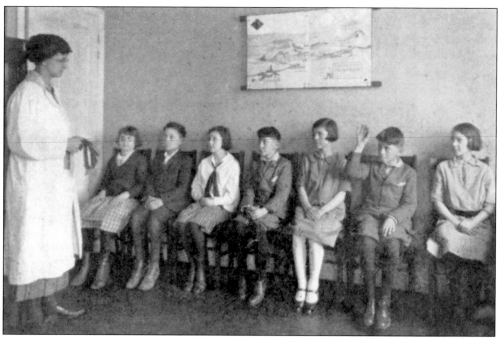

Among the classes for children offered by the department were nutrition, hygiene, and infection prevention.

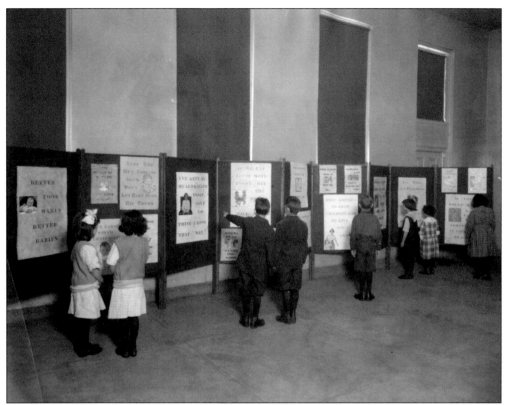

In this 1922 photograph, schoolchildren visit the Department of Disease Prevention for a health fair. Lining the room are health propaganda posters with the following messages: "Better food makes better babies," "Even tho he is feeling glum, don't let baby suck his thumb," "Help America to show children how to live and grow," and "I've kept my health rules today. Don't you think I look that way?"

At the Department of Disease Prevention, children were taught using play. In 1921, a theatrical performance was staged about the virtues of good nutrition.

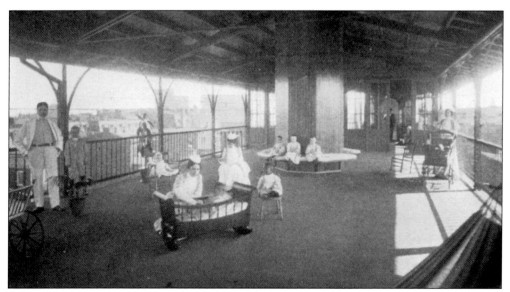

Nurses carried patients to the roof to promote healing through sunlight and fresh air. An elevator was installed at the Locust Street location in 1900 so that the larger bedridden children and those too ill or in too much pain to be carried up the stairs could also receive the prescribed fresh air and sunlight. The 1899 annual report stated, "During the past summer it proved a valuable aid to treatment, especially for the babies and convalescents, who are thus enabled to enjoy, with little trouble and fatigue, a greater amount of sunlight and a fresher and cooler air—factors so essential to their well-being."

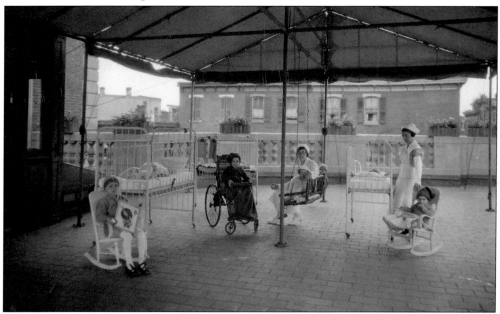

The frequent use of the rooftop garden's "fresh air therapy" continued into the 20th century. This photograph was taken in 1923, when sun therapy was prescribed to patients. Even in cold weather, nurses were required to take children to the outdoor area of the hospital to receive their daily prescription of sun therapy. The rooftop garden was incorporated into the Bainbridge Street design to facilitate a therapeutic environment.

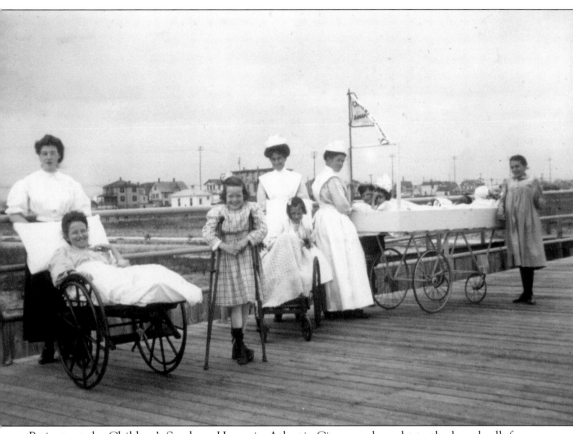

Patients at the Children's Seashore House in Atlantic City were brought to the boardwalk for a dose of sunlight and fresh air as part of their regular therapy. One such outing is captured in this photograph from 1910.

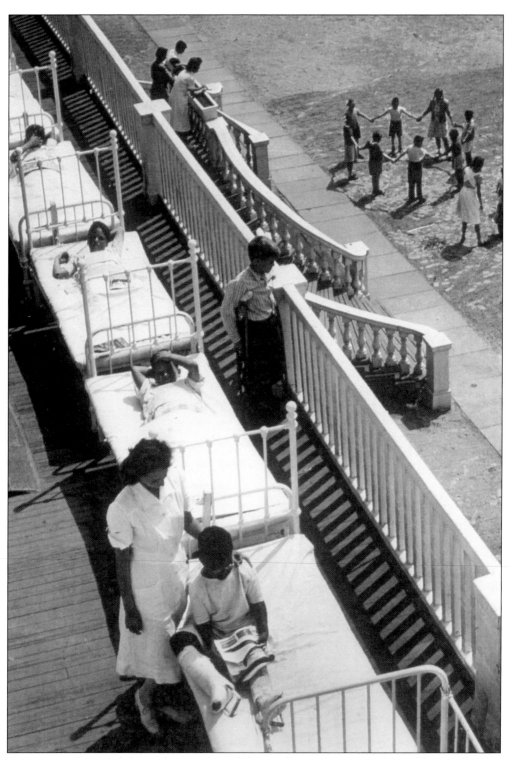

For young patients and those who were immobile, porches were consistently used for sun therapy, as seen here on the large deck of Whitney Hall at the Children's Seashore House in 1932.

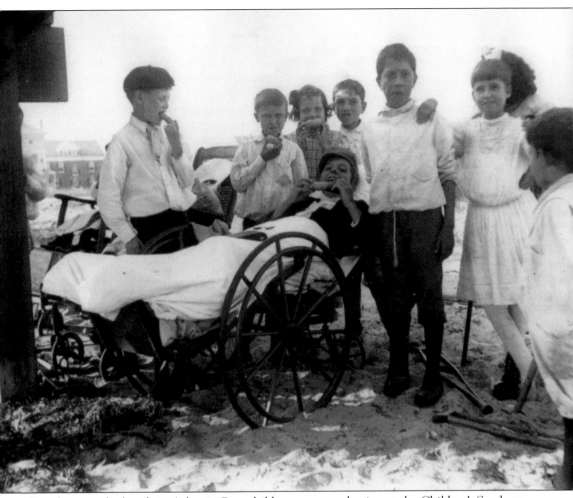

Seen here on the beach in Atlantic City, children are convalescing at the Children's Seashore House in the 1920s. Each day included four meals, a bathing hour in the ocean in the late morning, and seaside activities in the afternoon. Patients were transported from The Children's Hospital of Philadelphia to the Children's Seashore House during the summer months. When a higher acuity of care was needed, patients were transferred back to the hospital.

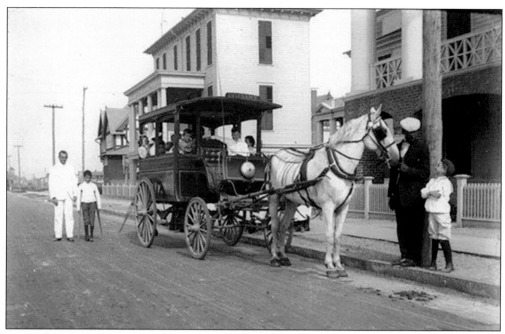

Patients traveled by train from Philadelphia hospitals to the Children's Seashore House in Atlantic City. The house had a horse-drawn carriage to transport patients back and forth from the train station to the house and a mother's cottage. Just south of the house was a boys' camp for patients, and the ambulance was used to shuttle those children back and forth from camp to the house.

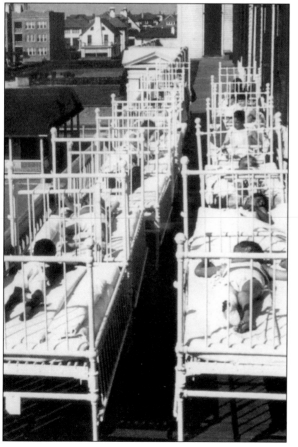

Cribs are lined up on the porch at the Children's Seashore House in Atlantic City. The ocean air was thought to have medicinal value for the children. In 1878, founding physician Dr. William Bennett noted, "The children acquired a deep tan which together with rest, ocean air and generous supply of nourishing food cured most of the cases of the gland, bone and joint tuberculosis."

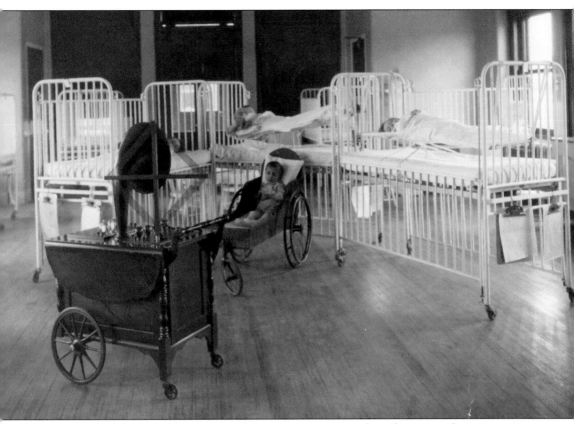

An example of early music therapy is seen here as postoperative orthopedic patients listen to music on a radio, which Mrs. Harrison Smith had donated to the hospital in 1924 for "radio parties."

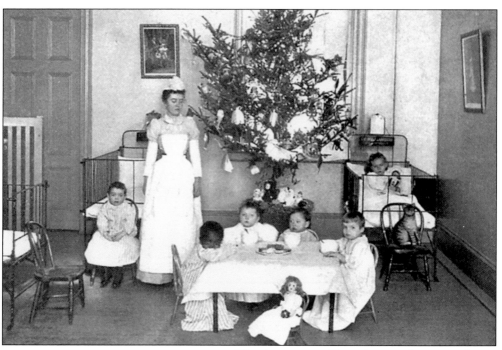

1915.

Babes Cry for a Chance

"JOSEPH"

"TINY MARY JONES"

The Amusement Committee made certain that children were able to celebrate holidays at the hospital. An annual Christmas fund was created to raise money for holiday celebrations. The 1899 annual report stated, "The children had their usual Christmas trees, which were trimmed by the Amusement Committee and were gay with many toys and decorations provided by a friend of the Hospital. Another friend, as for many years past, gave each child a stocking filled with toys. Many dolls and toys were given to poor children coming to the Dispensary during the holidays, who, even more than the inmates of the Hospital, needed Christmas cheer."

A 1915 newspaper article featured the home visiting nurse program, which began as an extension of the Department of Disease Prevention. The program was discontinued in 1939. A new hospital-based home care program, the first of its kind in the nation, was started in 1962 but came to an end in the 1970s. Children's Hospital Home Care, a comprehensive home care department, opened in 1988, and it is still in existence today as a full-service, hospital-based home care department.

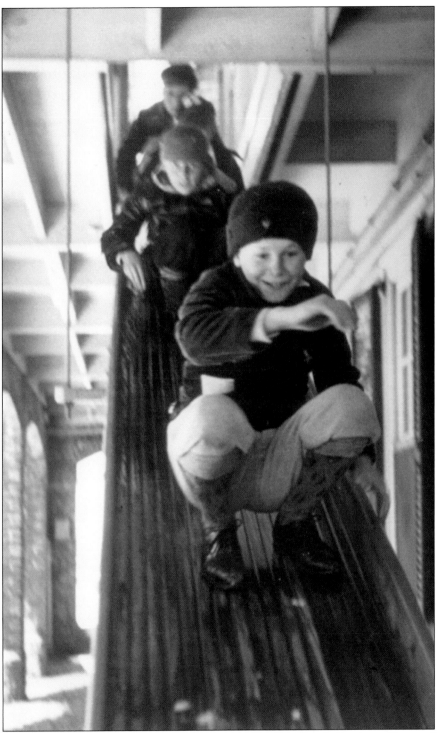

Playtime was regularly incorporated into therapy at the Children's Seashore House. A slide and other play equipment were installed under the large porch of Whitney Hall, as seen in this undated photograph.

In 1874, children with eye and ear surgery were separated from medical patients in a new ward. The separation of medical and surgical patients continued well into the early 20th century, as seen in this 1930 photograph of a baby receiving postoperative care. According to the 1874 annual report, "For the isolation and treatment of certain affections of the eye and ear, for many of the former which the exclusion of light is an indispensable element for cure. For obvious reasons, it would also be desirable to have special accommodation for patients during convalescence, the progress toward cure in many such cases being undoubtedly retarded by retaining them in a more or less contaminated atmosphere of the general ward."

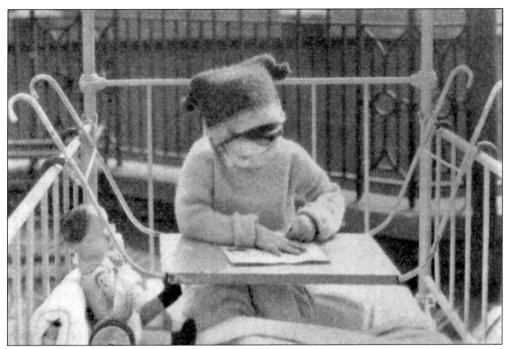

Play activities continued as a regular component of care, as seen in this photograph of an inpatient child busy at play on the rooftop garden in 1928.

Outpatient dispensaries continued well into the 19th century. The 1928 annual report featured an update on the surgical dispensary, seen behind the postoperative patient in this photograph.

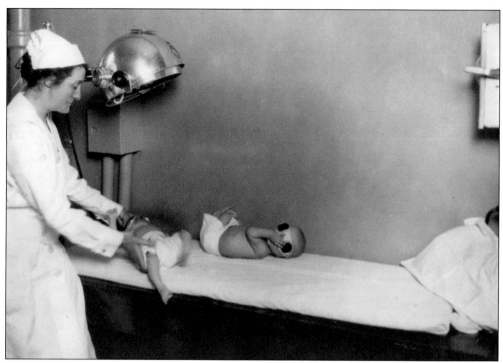

In this 1924 photograph, two infants receive phototherapy for rickets. Phototherapy was developed at Harvard, but its early use was recorded at The Children's Hospital of Philadelphia.

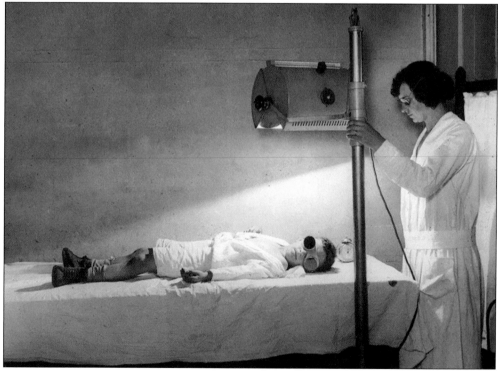

A school-age boy is undergoing a phototherapy treatment for rickets in this undated photograph.

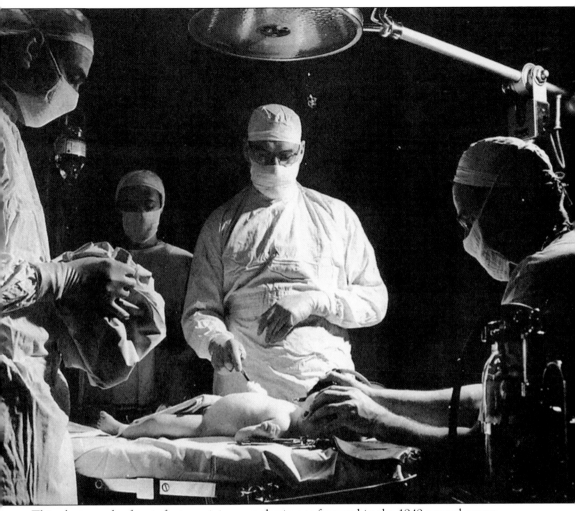

This photograph of an infant receiving anesthetic was featured in the 1949 annual report.

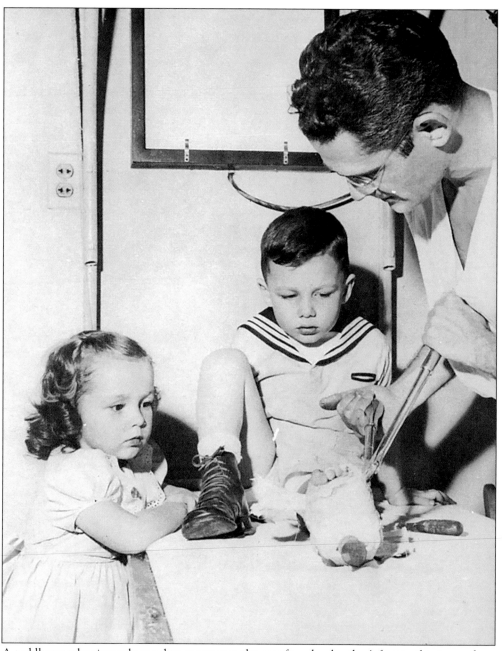

A toddler watches intently as a doctor removes the cast from her brother's foot in this image from the 1949 annual report.

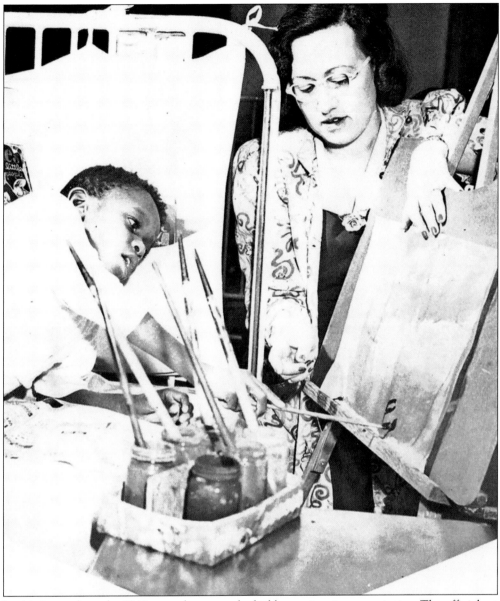

In this image from the 1949 annual report, a bedridden patient is seen painting. The official art therapy program was not started at the hospital until 1997, when it became an extension of child life and creative arts therapy.

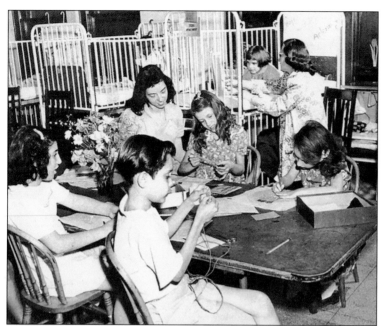

Group sessions of occupational therapy were held at the bedside until gyms were built at the civic center hospital location in 1974. This image is from the 1949 annual report.

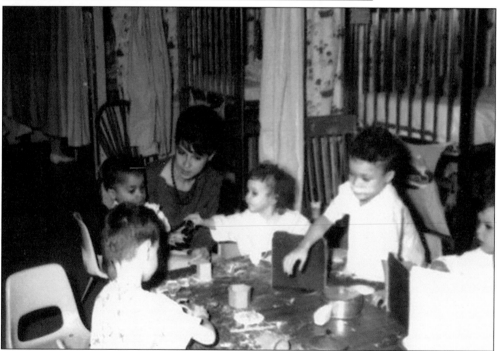

The following is an excerpt from a 1967 report on the psychiatry department: "The Hospital's play program, conducted under the aegis of the Department of Psychiatry, helps create a comfortable atmosphere for young patients. Meals are served family style. When the weather is pleasant, children play out of doors. Very sick youngsters, who cannot participate in play activities, enjoy watching the other children. The Hospital's play ladies, who hold degrees in early childhood education, determine how the patients are coping with the trauma of hospitalization. An integral part of the care team, play ladies confer with doctors and nurses."

The formal Department of Child Life started at The Children's Hospital of Philadelphia in 1951. A "play lady," later called a child life specialist, comforts a child in this 1967 photograph.

An integral part of the care team, child life specialists prepare a child for upcoming surgery in 1998.

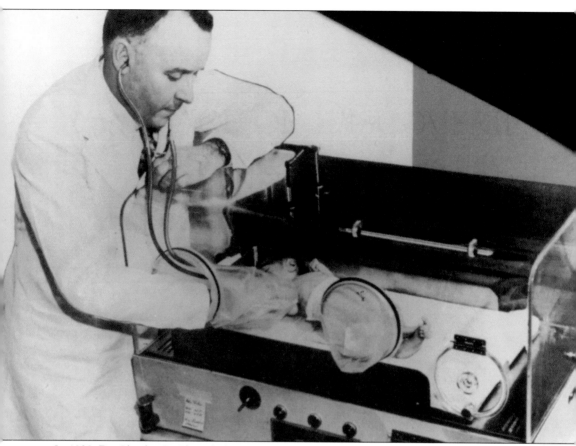

In 1938, Dr. Charles C. Chapple (1903–1979) published a medical paper in which he described a new "closed chamber," eventually called the Isolette, for controlling the environment of premature infants. He is pictured here with a version of this device from the late 1940s.

Three

A PLACE OF DISCOVERIES AND FIRSTS
PIONEERS IN CHILDREN'S HEALTH

As the first US hospital dedicated to caring exclusively for sick children, The Children's Hospital of Philadelphia has maintained a culture that expects, supports, and celebrates any innovation or discovery that improves the health of children.

The integration of unique family-focused patient care, cutting-edge research, and a commitment to training the next generation of pediatric clinicians has resulted in a remarkable track record of discovery and leadership. For example, the honor of being the first pediatric trainee goes to Rudolfo Valdeviseo, a native of Chile and graduate of the University of Pennsylvania School of Medicine. Appointed in 1871, he spent a year preparing medicines for sick children. He was not paid for his year of service, but received a hearty thank-you.

In 1877, a system of competitive examination was instituted to select the best resident physicians to train at the hospital. Today, the Pediatric Residency Program at The Children's Hospital of Philadelphia is among the most competitive in the United States.

The pioneers at The Children's Hospital of Philadelphia realized that children were not "small adults." The growing and developing child had unique physiological and nutritional needs that led to the development of new special care, medical devices, vaccines, and therapies, all focused on improving the health of children. T. McNair Scott, the first director of the Department of Research, focused both on research and patient care. He was instrumental in extending the very restrictive pediatric hospital visiting hours. In the 1940s and 1950s, hospital stays were long. In many cases, parents were allowed to visit only once or twice a month. The Children's Hospital of Philadelphia was the first to encourage daily visits, a notion that was rapidly adopted nationwide. This family-centered policy was a major therapeutic advance. With parents on hand, the children's nutrition improved, as did their mood, and therefore, they recovered more quickly.

The images that follow highlight some of the leading physicians responsible for discoveries, as well as the innovative programs that were developed. Their contributions continue to shape the hospital of today.

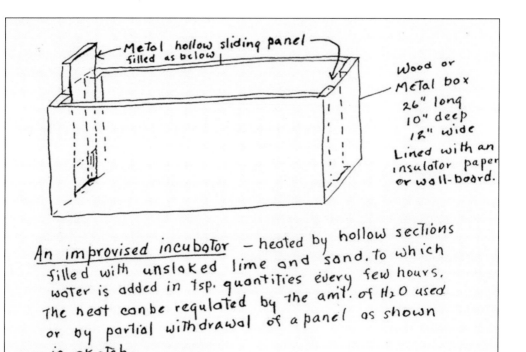

← Metal hollow sliding panel
filled as below

Wood or Metal box
26" long
10" deep
12" wide
Lined with an insulator paper or wall-board.

An improvised incubator — heated by hollow sections filled with unslaked lime and sand, to which water is added in tsp. quantities every few hours. The heat can be regulated by the amt. of H_2O used or by partial withdrawal of a panel as shown in sketch.

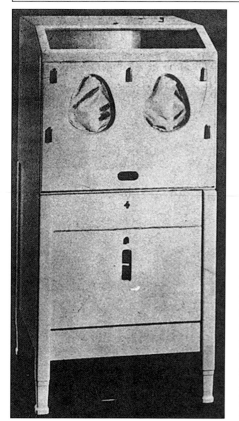

Dr. Chapple kept his original sketch of the Isolette from the 1930s. Versions of Dr. Chapple's original Isolette were soon used throughout the world.

Dr. Chapple's invention was designed to protect infants from airborne infections by sealing them off from the outside environment in a chamber with controlled temperature, humidity, and oxygen and carbon dioxide levels. With his design, the infants were fully visible and could be touched and tended to through a set of attached sleeves. After World War II, Dr. Chapple redesigned his invention using Lucite, and the new model officially became known as the Isolette.

The first hospital social worker was appointed in 1911, and in 1914, Howard Childs Carpenter, MD, (1878–1955) established the first Department of Disease Prevention for children, seen to the right of the car in this photograph. The first of its kind in the nation, the department used the skills of physicians, nurses, and health educators to prevent diseases, such as smallpox, scurvy, and diphtheria. Visitors came from around the world to learn about this novel approach to disease prevention pioneered by Dr. Carpenter. In 1939, the department was closed, but many of the activities were incorporated into the Philadelphia Department of Health and the outpatient services of the hospital.

The Catherwood Milk Laboratory was established in 1900. Nursing students received instruction on the study of preparation for various milk mixtures and other special foods for infants. It took several decades of research for infant feeding to progress to the point where cow's milk could be modified enough to replace human breast milk. Research at the hospital made it possible to introduce homogenized milk to the public in 1940, as a result of the work by Dr. I.J. Wolman and his collaborators.

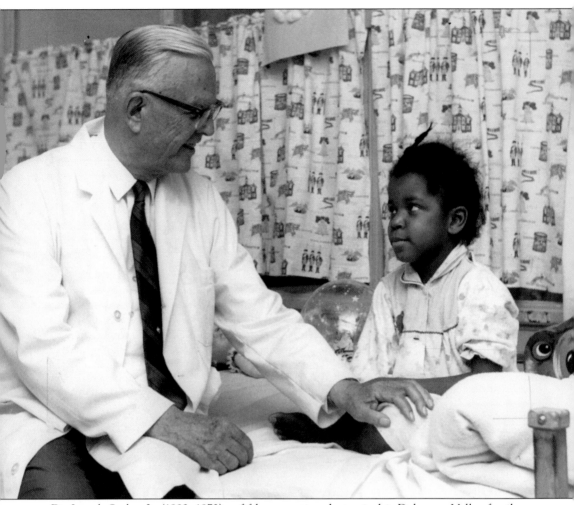

Dr. Joseph Stokes Jr. (1892–1972), a fifth-generation doctor in his Delaware Valley family, was appointed as the second physician-in-chief and chairman of the Department of Pediatrics from 1939 to 1961. Stokes is credited with transforming the hospital into a world leader in pediatric research and medical education. The current Stokes Auditorium is named in honor of his father, Dr. Joseph Stokes Sr., who served as an intern at the hospital in 1883 after graduating from the University of Pennsylvania School of Medicine. Joseph Stokes Jr. began working at the hospital in 1922 and spent most of his career studying infectious diseases, with a focus on vaccine development. In addition to his accomplishments as a pediatrician, he served as the consul general of Japan, and in 1946, Pres. Harry S. Truman awarded him the Medal of Freedom for his work in which he ascertained the value of gamma globulin for the prevention of epidemic hepatitis and serum hepatitis. Taken after his semiretirement in 1967, this photograph of Dr. Stokes Jr. with a patient was used in a January 1968 article in the *Philadelphia Inquirer* about his lifetime of service.

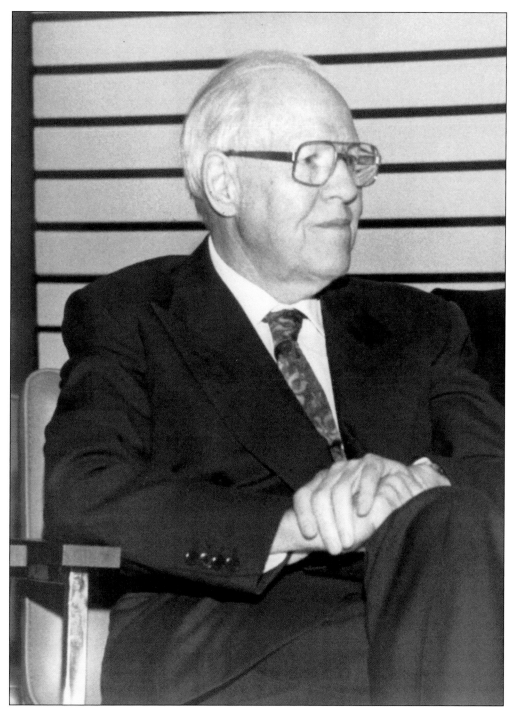

Dr. T. McNair Scott (1901–2001) was appointed as the first director of research by Dr. Joseph Stokes Jr. in 1940. He held this post until 1966, except for a brief hiatus while serving in World War II. His research focused on viruses, and the early use of tissue culture to grow viruses, which were vital to the characterization and diagnosis of viral illnesses in children. He and Dr. Thomas Rivers discovered one of the viral causes of meningitis, the lymphocytic choriomeningitis virus.

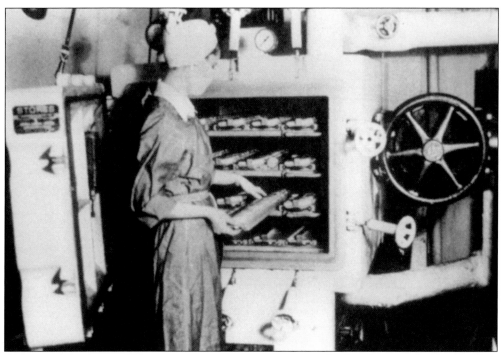

In this photograph, a technician is seen processing serum to prevent pertussis, or whooping cough, in 1938. Before the use of the pertussis vaccine, serum was used in an effort to prevent the spread of the disease. The hospital processed serum, which was distributed to 48 states and 17 foreign countries.

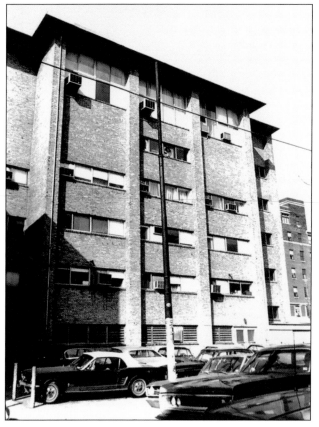

Pictured here is the hospital research building at Seventeenth and Bainbridge Streets in February 1971, shortly before Dr. Klaus Hummler became the first director of the newly named Joseph Stokes Jr. Research Institute. The building opened in 1954 and cost $843,000 to build and fully equip. The board of managers first appropriated hospital funds to support research in 1937.

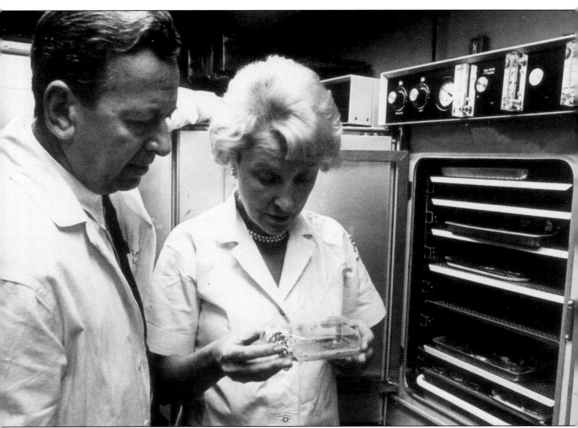

Werner Henle (1910–1987) and Gertrude Henle (1912–2006) were a husband-and-wife team who focused their research on viruses. Together with Joseph Stokes Jr., they showed that gamma globulin was an effective therapy for Hepatitis A. They were also responsible for discovering the connection between the Epstein-Barr virus (EBV) and the development of Burkitt's lymphoma, the first time that a virus had been shown to cause cancer.

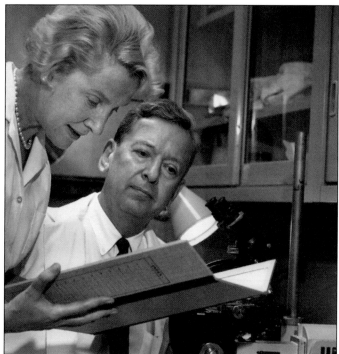

The Henles also proved that the Epstein-Barr virus was a cause of mononucleosis, or "the kissing disease." The husband-and-wife research team retired together in 1982.

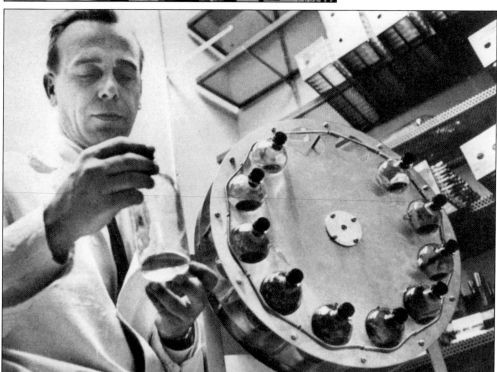

Klaus Hummler was the first director of the newly formed Joseph Stokes Jr. Research Institute in 1972, and he served in that role until his retirement in 1989. Dr. Hummler, shown here in 1954, was a pioneer in the use of electron microscopy.

Dr. Hummler was a collaborator with the Henles on the link between the Epstein-Barr virus and Burkitt's lymphoma. He and Mary N. Crawford, MD, pictured here together, identified over 20 viruses and their related diseases. Hummler and the Henles opened the first clinical virology lab in a children's hospital in the country.

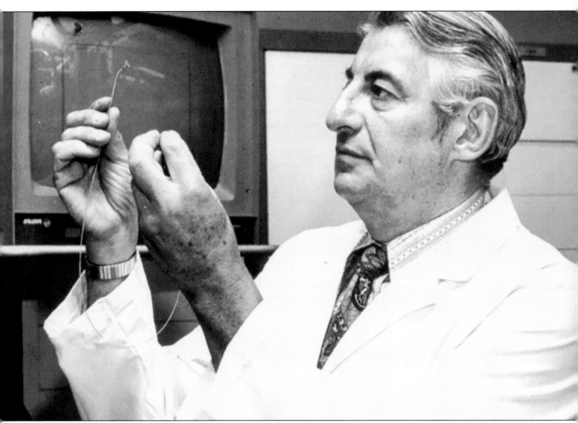

The cardiology department of the hospital began in the 1920s amid studies of rheumatic fever. By 1937, the hospital had developed a cardiology service, which was headed by Dr. Rachael Ash. Ten years later, she became the director of the entire cardiology service. She was later replaced by Dr. William J. Rashkind (1922–1986), a pediatric cardiologist and one of the fathers in the field of interventional catheterization. Dr. Rashkind developed a lifesaving, nonsurgical procedure for infants with a type of congenital heart disease. The "balloon atrial septostomy" is also referred to as the Rashkind procedure. He is shown here in 1965 holding the catheter used to perform the procedure.

Preliminary Communication

Creation of an Atrial Septal Defect Without Thoracotomy

A Palliative Approach to Complete Transposition of the Great Arteries

William J. Rashkind, MD, and William W. Miller, MD

Transposition of the great vessels (TGV) occurs in approximately 20% of children who die with congenital heart disease.[1] With rare exceptions, patients with this lesion die in the first 6 months of life (50% within the first month). Approximately 40% of patients with TGV have an otherwise normal heart. In recent years, various types of complete corrections for this lesion have been attempted. Mustard et al[2] has simplified these procedures and has reduced mortality to reasonable levels. Best results are obtained in children well beyond 6 months of age. Therefore, it is imperative to provide early palliation that is effective until the optimal age for complete correction and that does not interfere significantly with subsequent surgery. Creation of an interatrial communication seems the best available choice to suit these requirements. The Blalock-Hanlon technique,[3] or some modified version, is commonly used to remove a portion of the atrial septum surgically. The purpose of this report is to present a technique for producing an atrial septal defect without thoracotomy and without anesthesia, using a cardiac catheter introduced into a femoral vein.

Method and Material

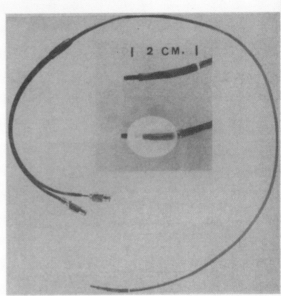

1. Illustration of the special balloon-tipped catheter (6.5 F). Insert shows the tip magnified in both deflated and inflated positions.

The medical paper describing the procedure was published in the *Journal of the American Medical Association* (JAMA) in 1966.

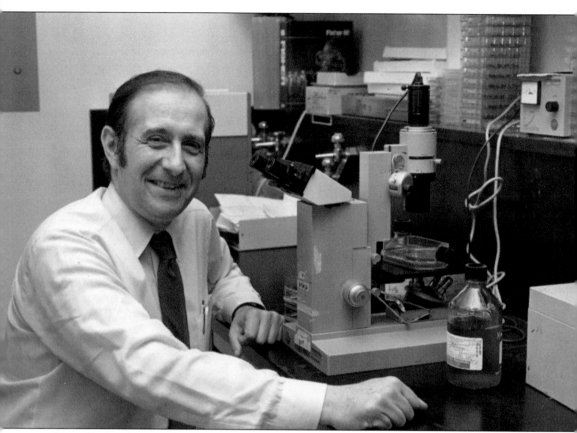

In 1963, Stanley A. Plotkin, MD, was the first division chief of infectious diseases, a role he served until he left the hospital in 1991. Seen here in 1985, Dr. Plotkin, a nationally renowned vaccinologist, developed the rubella, or German measles, vaccine now used around the world. He helped to develop the modern rabies vaccine and, most recently, worked with Drs. H. Fred Clark and Paul A. Offit in developing a vaccine against the rotavirus, a gastrointestinal infection of infants and children.

The rotavirus vaccine, developed at the hospital, began routine use in the United States in 2006. Since then, severe rotavirus disease in infants and children has substantially declined, preventing approximately 65,000 diarrhea-related hospitalizations from 2007 to 2009. The inventors of the vaccine are shown here receiving The Children's Hospital of Philadelphia Medal of Honor for their contributions to improving child health around the globe. From the left to right are Drs. H. Fred Clark, Stanley A. Plotkin, and Paul A. Offit.

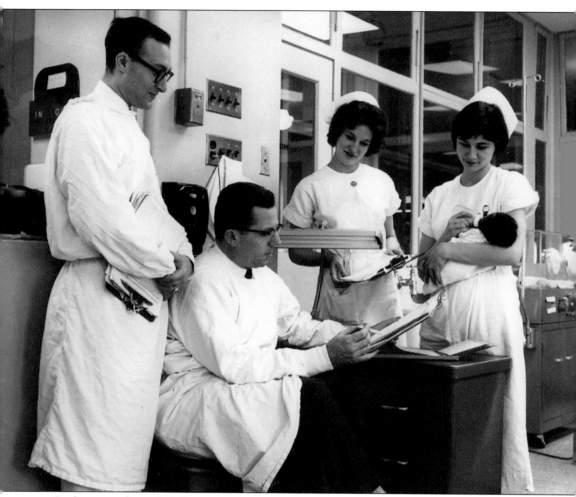

In this image from 1962, Dr. C. Everett Koop is seen conducting rounds in the neonatal intensive care unit (NICU). Dr. Koop started the first surgical NICU in the country in 1963. Initially, the unit was situated next to the operating room, and in 1970, under the direction of medical director George Peckham, MD, it ultimately expanded to include medical neonates.

C. Everett Koop (1916–2013) was the surgeon-in-chief at the hospital from 1948 to 1981, when he left to become the US surgeon general. Dr. Koop was an innovator of improved operative techniques, including the separation of conjoined twins, which allowed his team to achieve the nation's best survival rates for infants with life-threatening birth defects. He is seen here in the 1960s collaborating with a nurse in the NICU.

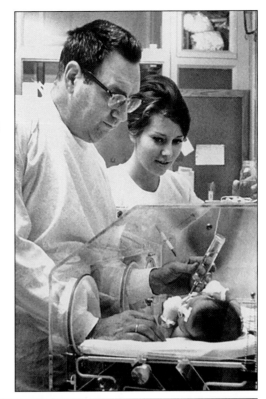

Initially, the infant ward was one open room, but in the early 1960s, dividers were put in place to provide a barrier between patients.

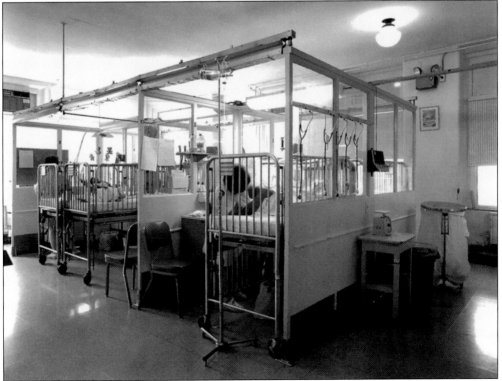

Preliminary Communication

Growth and Development of an Infant Receiving All Nutrients Exclusively by Vein

Douglas W. Wilmore, MD, and Stanley J. Dudrick, MD

An infant weighing 2,300 gm (5 lb 1 oz) with atresia of the small bowel from the ligament of Treitz to within 3 cm of the ileocecal junction, and partial atresia of the colon, declined postoperatively to 1,816 gm (4 lb) despite vigorous but conventional supportive care. A 30% solution containing all required nitrogen, calories, and essential nutrients was then infused continuously into the superior vena cava for 44 days when gastrointestinal dysfunction precluded enteral feeding. During the period when nutrition was given entirely intravenously, normal growth and development accompanied increases of 5.0 cm (1.9 in) in head circumference, 6.3 cm (2.5 in) in length, and 1,447 gm (3 lb 3 oz) in weight.

following severe protracted vomiting. Roentgenographic examination of the abdomen showed a dilated fluid-filled stomach and duodenum with absent gas-pattern distal to the ligament of Treitz. Roentgenograms following barium sulfate enema revealed obstruction of the radiopaque column at the midsigmoid colon. She was referred to Children's Hospital of Philadelphia for surgical treatment.

On admission the baby appeared mottled, dehydrated, and lethargic. Her temperature was 34 C (93.2 F); pulse rate was 160 beats per minute; there were 64 respirations per minute; and she weighed 1.5 kg (3 lb 5 oz). The chest was clear to auscultation. Heart sounds were normal without murmurs. The abdomen was soft to palpation and no masses were noted. Liver and spleen were not palpated. Bowel sounds were absent and no meconium was present in the rectum.

This medical paper by Drs. Wilmore and Dubrick, published in the *Journal of the American Medical Association* (JAMA) in 1968, is the first description of a method to provide intravenous nutrition to a critically ill infant. Advances in the care of critical infants and children were pioneered at The Children's Hospital of Philadelphia.

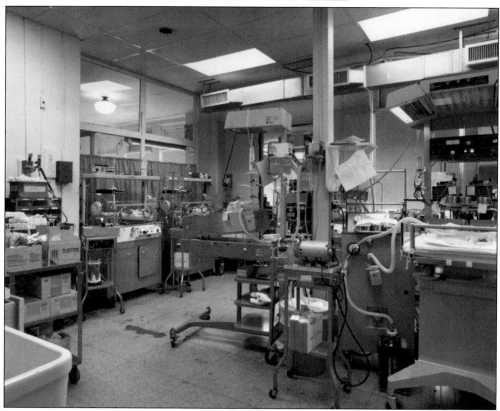

After the move to the new hospital in 1974, the old hospital was photographed without patients or staff. Dr. Koop recounted the story of walking through the operating rooms and the NICU for one last nostalgic look before moving to the new hospital, where there would be 20 new infant intensive care beds. The hospital now houses a 98-bed newborn intensive care unit and manages an extensive network of community hospital NICUs.

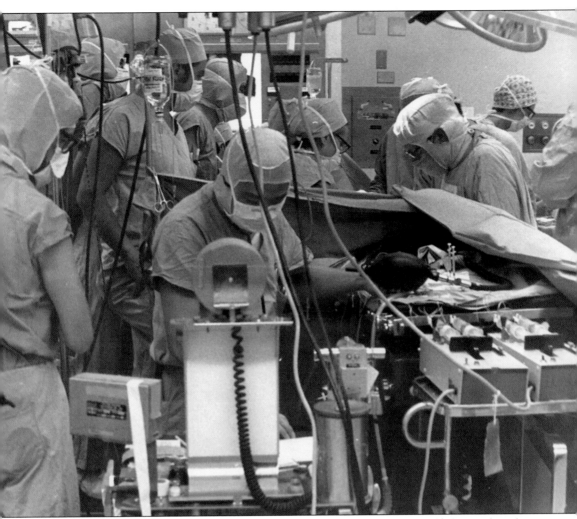

Seen here under the direction of Dr. C. Everett Koop, the surgical team at the hospital works to separate conjoined twins Clara and Alta Rodriguez in September 1974. It took a total of 26 doctors and nurses eight hours to do the surgery. After an 82-day inpatient stay, the healthy twins returned to their home in the Dominican Republic. Dr. Koop separated the first conjoined twins in 1957. Over the years, the hospital has developed a reputation as a world leader in the surgical evaluation, separation, and care of conjoined twins.

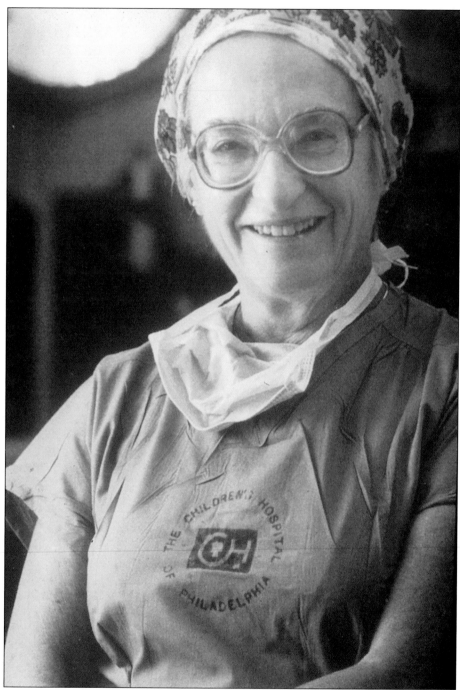

Dr. Louise Schnaufer (1925–2011) was a pioneering pediatric surgeon recruited to the hospital by Dr. Koop in 1971. Known as a skillful diagnostician and outstanding teacher, she joined Dr. Koop to perform a series of challenging operations to separate conjoined twins in the 1970s. Dr. Schnaufer was one of many female physicians to contribute to the rich history of the hospital. In 1904, the first female physician appointed to the staff was Margaret F. Butler, an aural surgeon who spent time working in the surgical dispensary and performing surgeries.

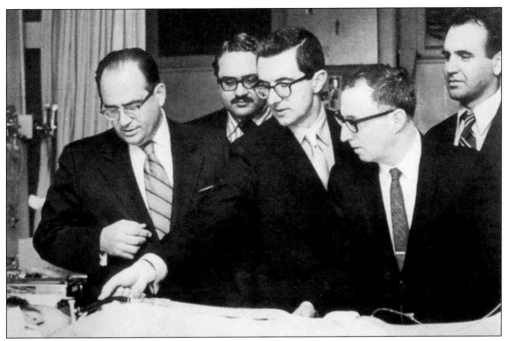

Dr. Leonard Bachman and Dr. Jack Downes opened and directed the first intensive care unit exclusively for children. Initially, the unit had four beds at the Bainbridge Street location. Dr. Downes solicited volunteers from the Radio Corporation of American (RCA) to help the physicians design the initial pediatric intensive care unit in the current hospital, which has since been replaced by a 55-bed unit, with a separate 24-bed unit for children on long-term ventilator support. Dr. Downes is pictured here with his hand on the patient's breathing tube in the 1960s, and to his right is Dr. Bachman, along with visiting physicians from the former Soviet Union.

Nurses care for a patient in the pediatric intensive care unit at the new hospital location in 1974.

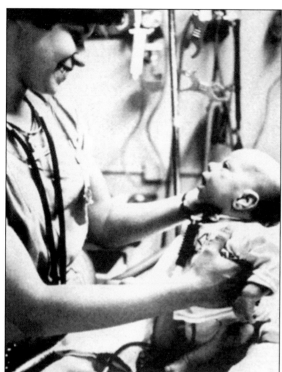

Pictured sometime in the 1960s, a nurse cares for a patient in the pediatric intensive care unit at the Bainbridge Street location. (Courtesy of Dr. Jack Downes.)

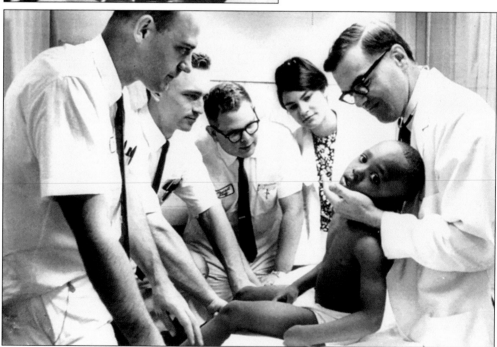

Dr. David Cornfeld (1927–1993) was the first chief of the Division of General Pediatrics at the hospital. He was a superb teacher, both at the bedside and in the classroom. His teachings, known as Cornfeld Rounds, taught skills in diagnosis. He is pictured here with a group of pediatric residents in the 1970s.

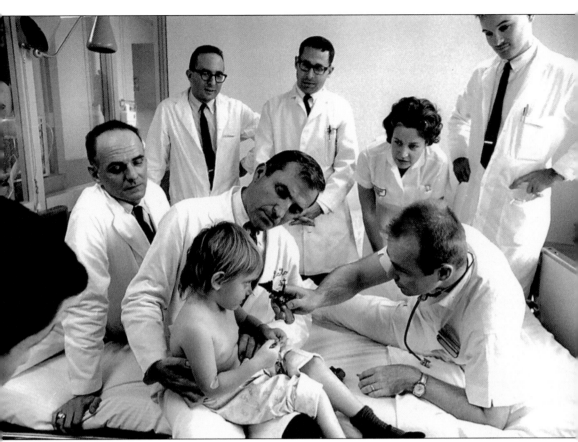

Pictured here is a group of residents and faculty examining a patient in the 1960s. Dr. Alfred M. Bongiovanni (seated at left, on the patient's bed) was the third physician to serve as chairman of the Department of Pediatrics, from 1963 to 1972. Dr. Bongiovanni was internationally known for his research in endocrinology, with a focus on growth problems in children.

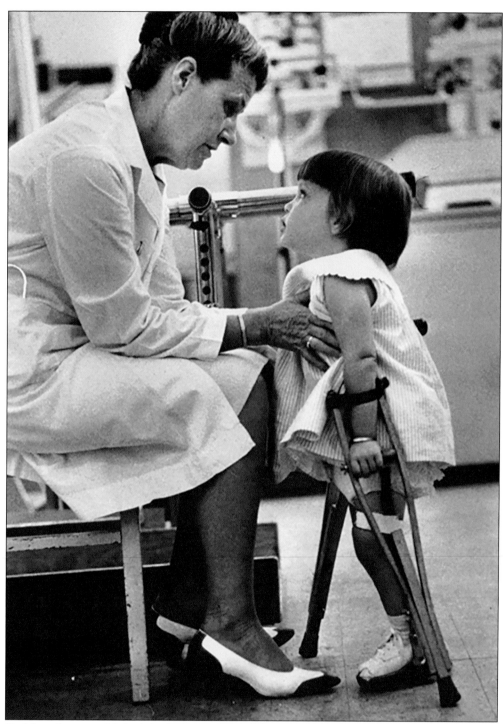

Dr. Mary Ames established the Division of Rehabilitation in 1962. She started the first clinic for children with spinal cord defects and dedicated herself to caring for children with multiple handicaps. She always carried a screwdriver and pliers in her lab coat for minor repairs of patient braces.

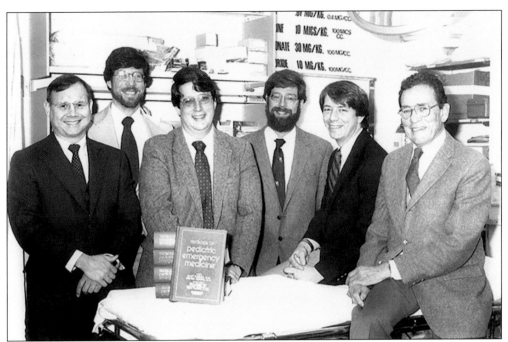

Dr. Stephen Ludwig was a leader in the development of the field of pediatric emergency medicine. Dr. Ludwig (third from the left) is pictured here with his fellow editors, celebrating the publication of the first edition of the *Textbook of Pediatric Emergency Medicine* in 1983. From left to right are Dr. John Templeton, Dr. Gary Fleisher, Dr. Stephen Ludwig, Dr. Fred Henretig, Dr. Richard Ruddy, and Dr. Ben Silverman. (Courtesy of Dr. Stephen Ludwig.)

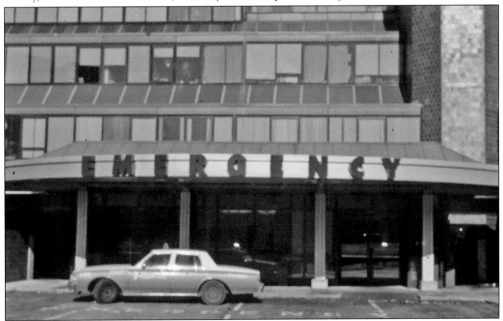

Established in 1977, the hospital's emergency department was the first in the nation to staff its emergency rooms with full-time pediatric emergency medicine faculty 24 hours a day. (Courtesy of Dr. Steven Selbst.)

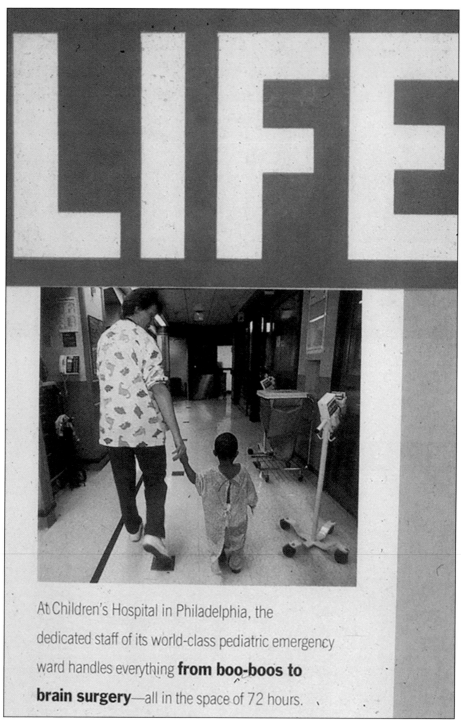

At Children's Hospital in Philadelphia, the dedicated staff of its world-class pediatric emergency ward handles everything **from boo-boos to brain surgery**—all in the space of 72 hours.

The front cover of *LIFE* magazine heralds the world-class care provided in the emergency department. In 1980, the hospital's emergency medicine program was the first to offer special fellowship training in pediatric emergency medicine. The training program exclusively focuses on the emergency care of infants and children.

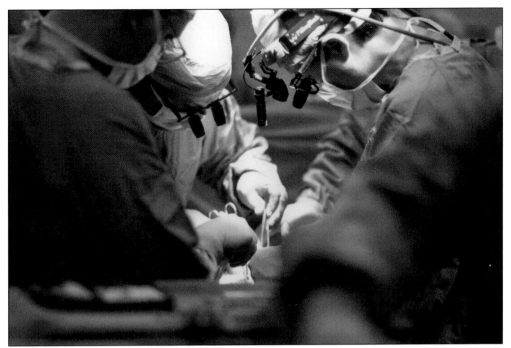

In 1996, Dr. N. Scott Adzick (right), surgeon-in-chief of The Children's Hospital of Philadelphia, performed the first open fetal surgery. His dedicated team has developed innovative surgical techniques and devices to operate on a fetus, then return it to the mother's womb. In 2008, the first birthing unit devoted to the care of mothers carrying a fetus with a birth defect was opened at the hospital. (Courtesy of Dr. N. Scott Adzick and The Children's Hospital of Philadelphia Public Relations Department.)

This dramatic photograph provides a glimpse into the pioneering advances in the care of a fetus with disabling birth defects. Pictured here is an open womb and the hand of a fetus during a fetal surgical procedure. (Courtesy of Dr. N. Scott Adzick and The Children's Hospital of Philadelphia Public Relations Department.)

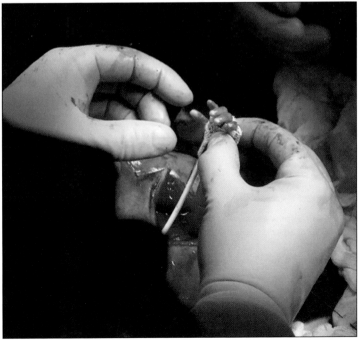

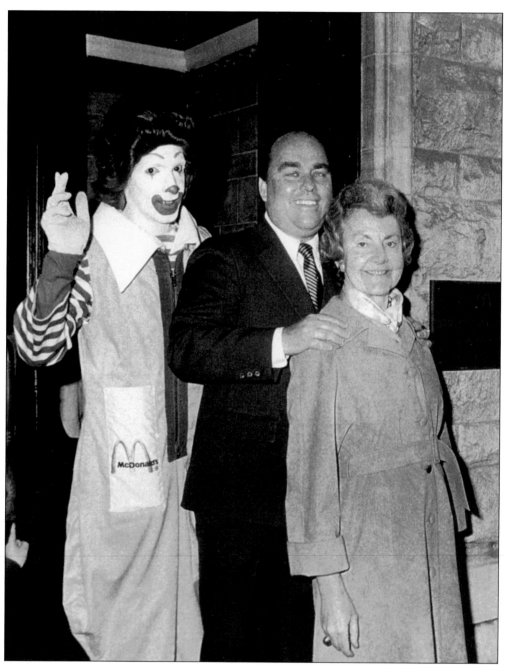

Oncologist Dr. Audrey Evans came to the hospital in 1970 to lead the Division of Oncology. At the time of her arrival, children with cancer were spread throughout the hospital. She created a discrete oncology unit with four initial inpatient beds. In 1974, Dr. Evans, always the pioneer, sought to help parents who spent night after night in the hospital with their ill children. Collaborating with Jimmy Murray, general manager of the Philadelphia Eagles, she created the first Ronald McDonald House in the country. She and Jimmy Murray are pictured here celebrating the opening of the first house, a respite for families caring for a hospitalized child.

Continuing its focus on family-centered care, Michele Lloyd, a former children's hospital executive, led the country with the development of the Connelly Family Resource Center, the first of its kind. The center, which includes a dedicated family library, sleeping rooms, kitchen, lockers, lounge, and education rooms, was made possible with a gift from the Connelly Family Foundation and design support from the hospital's Family Advisory Council. The center opened in 1997 and quickly became a model throughout the country. It continues to support families today with unique patient and family programming.

Mary Brooks was the first director of the Department of Child Life in the early 1960s. In 1967, Brooks cofounded the national professional organization, dedicated to improving the health care experience for children by providing play, preparation, and education programs. Modern child life providers are a critical part of the therapeutic team in helping children through difficult medical tests and treatments.

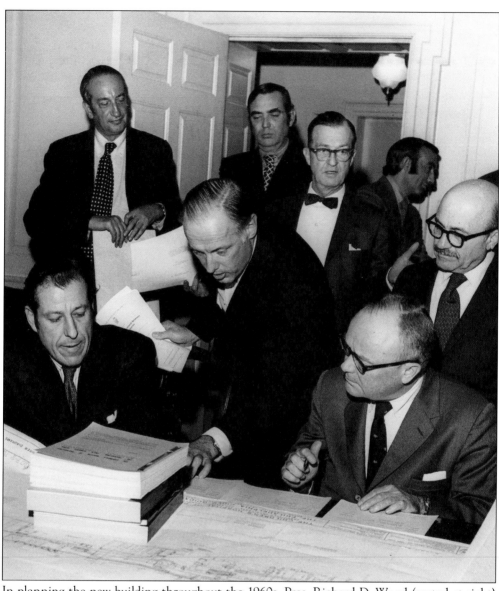

In planning the new building throughout the 1960s, Pres. Richard D. Wood (seated at right) held monthly Construction Control Committee meetings with hospital leaders, physicians, and architects.

Four

NEW HORIZONS
THE RISE OF THE NEXT GENERATION'S CHILDREN'S HOSPITAL

A continuing theme throughout the history of The Children's Hospital of Philadelphia has been exponential growth and the need for additional space. After years of additions and renovations, discussions about becoming a comprehensive medical center were first heard in 1936. It was not until 1951, however, that the hospital was officially declared a medical center and serious expansion plans to accommodate the hospital's three-part mission were under way.

In addition to 15 years of planning, the move to the fourth and final location required careful coordination with the city of Philadelphia, the Philadelphia General Hospital (which closed in 1968), and the University of Pennsylvania. A significant philanthropy campaign was launched to fund the construction of the new building.

Once the hospital settled into its current home, it was not long before new buildings were erected to support its mission. Several additions to the hospital were made, and new buildings devoted to basic science and clinical research provided the physical infrastructure needed to grow the hospital as a leading force in pediatric research and a top recipient of pediatric research funding from the National Institutes of Health. With investments in research have come breakthrough discoveries in multiple areas, including lifesaving vaccines, revolutionary cancer treatments, cures for congenital blindness, and lifesaving surgical interventions in the womb, among numerous other interventions. Over time, new innovations in patient care made it possible to deliver care in an outpatient setting, as well as at home. In 1989, the hospital opened the Wood Building, the first dedicated outpatient care facility on its campus. While the building was designed in anticipation of serving 140,000 outpatient visits per year, it saw more than 200,000 visits in 2014. The Buerger Center for Advanced Pediatric Care, a new 750,000-square-foot outpatient care facility on the hospital's main campus, has been planned for 2015, the hospital's 160th year.

In 1984, the hospital began to expand beyond its main campus, throughout the Philadelphia suburbs and into southern New Jersey to create what is today the largest children's hospital ambulatory network in the country. The CHOP Care Network, as it is now branded, consists of primary care practices, specialty care centers, day hospitals, ambulatory surgery centers, home care, urgent care, and partnerships with community hospitals.

The hospital's aspirations to become a world-class medical center have been fully realized. The leaders had a vision, and one would venture to guess that the hospital has surpassed that vision with the current campus and contributions to pediatric care around the world.

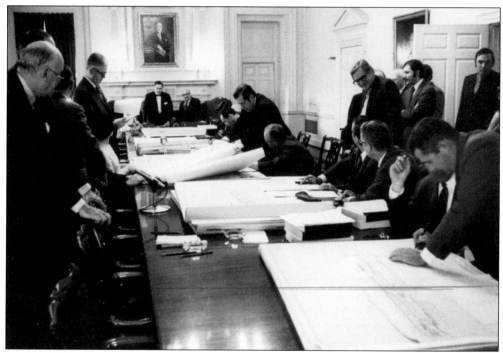

On December 7, 1970, the executive team, trustees, and architects gather at the First Pennsylvania Bank offices at Sixteenth and Market Streets to sign documents for Phase III of the hospital project. Board meetings and construction review meetings were held at this location due to space constraints at the Bainbridge Street hospital buildings.

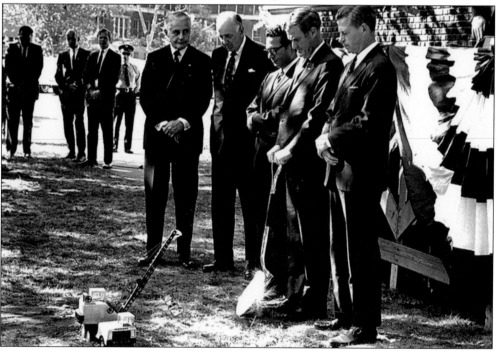

On September 19, 1968, the ground breaking for the new building began with a prayer.

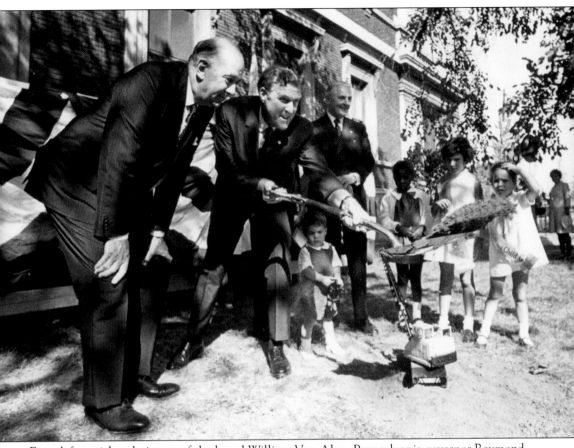

From left to right, chairman of the board William Van Alen, Pennsylvania governor Raymond Shafer, and Anderson Dilworth break ground for the new hospital. Children help with the task using a toy excavator.

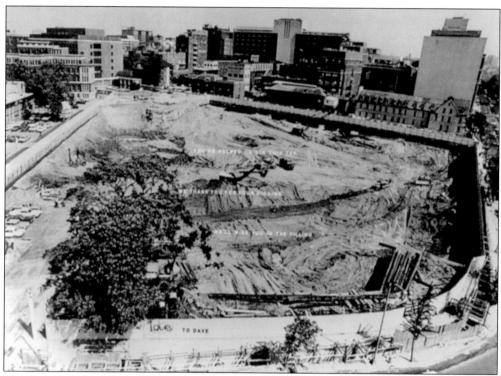

This photograph was signed by the board of trustees and sent as a thank-you and farewell in 1969 to David Oakley, director of the development department, in recognition of his fundraising efforts for the excavation of the new building.

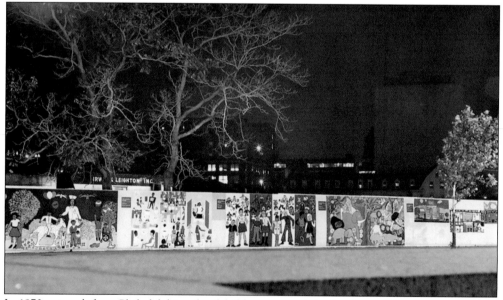

In 1970, artwork from Philadelphia schoolchildren covered the barrier wall for the construction site of the new hospital. Children were asked to envision what the new hospital would mean to them through painting parties that the hospital held outside the new campus as a way of engaging the community in the new building project.

Situated on a 5.1-acre plot of land on the site of the former Philadelphia General Hospital campus at Thirty-fourth Street and Civic Center Boulevard, the fourth home of The Children's Hospital of Philadelphia was completed in April 1974. In the early 1960s, the hospital received a grant from the US Public Health Service to explore the characteristics of a modern-day pediatric facility. Results of the extensive study were incorporated into the design of the new hospital, which included 272 beds, outpatient space, research laboratories, and substantial shelled space for future growth of the 94,000-square-foot building. Included in the study was the recommendation that a comprehensive pediatric medical center must have a close affiliation with a mental health facility. The Child Guidance Clinic shared the new building with a separate entrance to the left of the hospital's main entrance.

Community awareness for the new hospital was evident throughout the city of Philadelphia and surrounding region. During Dedication Week, which ran from April 28 to May 6, 1974, tours were offered to the community, with billboards and posters announcing its opening. By the end of Dedication Week, more than 5,000 visitors from the community had toured the hospital.

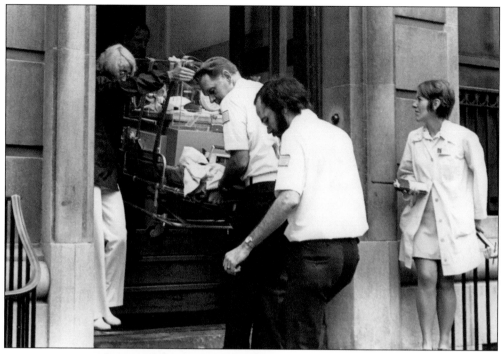

In a torrential downpour with raging winds, the move from Bainbridge Street to the new hospital began at 8:00 a.m. on June 23, 1974. Nurse Roseanne Passieri stands in front of the Bainbridge Street facility, orchestrating the complicated move of patients to the new hospital. Two-way radios were used to communicate between the two hospitals.

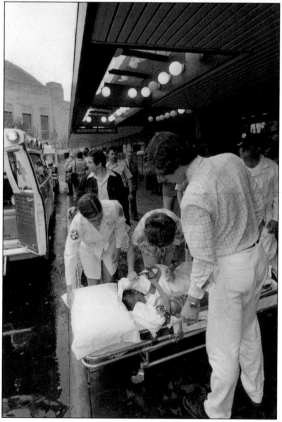

Here, 80 patients arrive on stretchers to the new hospital via 44 ambulances. An additional 100 nurses were interviewed and employed to assist with the complicated move. The patients were moved without incident over a three-hour span of time.

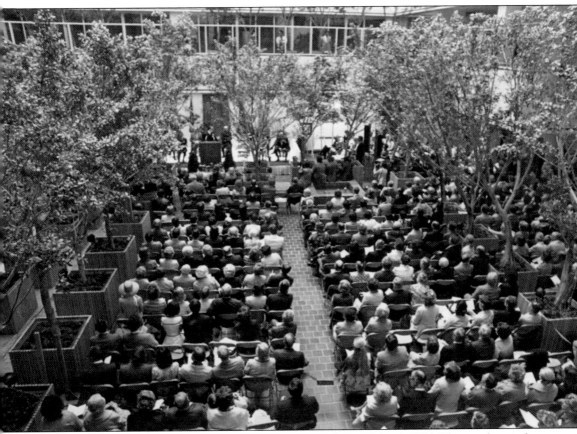

The inauguration of the hospital was held before moving day, on May 6, 1974. The new hospital had an open atrium lobby with ficus trees selected from the Florida Everglades. Dr. Koop was a prominent speaker for the opening event, which was attended by several hundred donors and dignitaries.

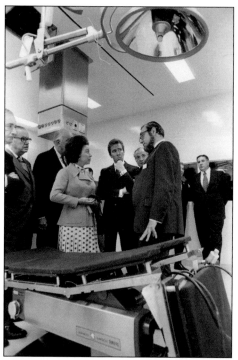

On May 6, 1974, the hospital held a dedication observation for state and international officials. Dr. C. Everett Koop (right, with a hand on the operating table) explains the surgical program and tours to, from left to right, ambassador to the Court of St. James Walter Annenberg, US senator Hugh D. Scott, chair of The Children's Hospital board of trustees William L. Van Allen, Her Royal Highness Princess Margaret, Lord Snowdon, Pennsylvania governor Milton J. Shapp, and Philadelphia mayor Frank Rizzo.

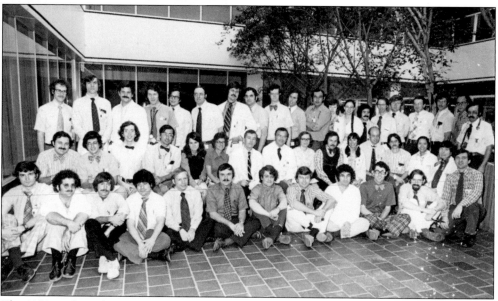

The 1974 resident class is pictured here. Seated in the center of the first row, seventh from left, is Alan Cohen, MD, then chief resident. Dr. Cohen was involved in the move of patients and volunteered for the overnight shift on the first night in the new hospital. Dr. Cohen later went on to serve for 12 years as the ninth physician-in-chief of the hospital and chairman of pediatrics for the University of Pennsylvania School of Medicine. Under his leadership, the Department of Pediatrics achieved a number one ranking in the country. Dr. Gene Courtner, chairman of pediatrics from 1972 to 1985, is seated seventh from left in the second row, directly behind Dr. Cohen. (Courtesy of Dr. Alan Cohen.)

Warren C. Falberg (left), executive vice president, and Charles E. Ingersoll, president, placed the dedication stone for the new hospital in June 1975.

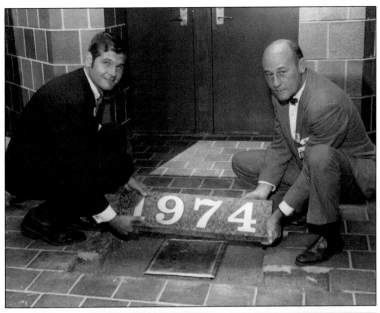

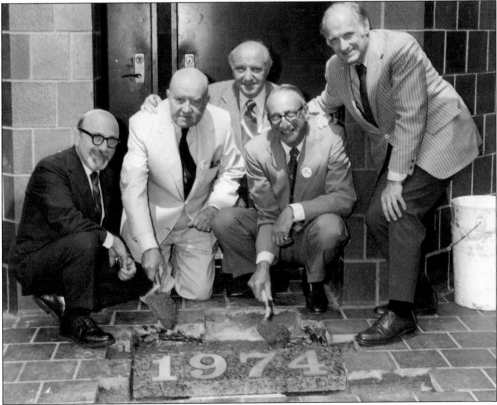

The opening of the new hospital created a financial strain on facility operations. In the early years, trustees and administrators feared that the hospital was larger than needed, and grave concern was expressed over the ability to provide ongoing operational support. Seen here in the first year of operations are members of the board of trustees placing the date stone in June 1975.

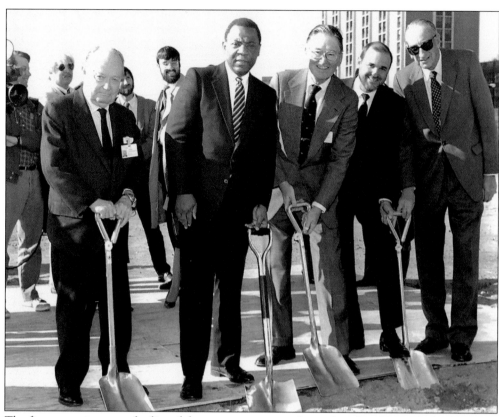

The first outpatient care facility of the new campus was planned in the 1980s. The building was named for Richard D. Wood, longtime president and chairman of the board of trustees. The ground breaking for the new building was held on November 16, 1987. From left to right are Richard D. Wood, chairman of the board of trustees; Wilson Goode, mayor; Frank R. Wallace, trustee; Edmond F. Notebaert, president and CEO; and Robert Fleisher, chairman of the board of trustees for the Building and Grounds Committee.

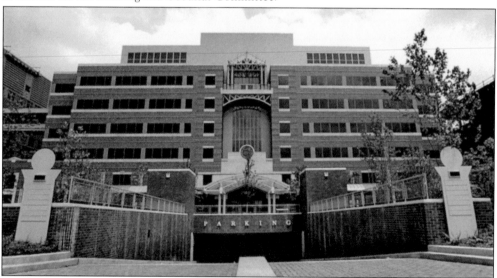

On May 20, 1988, Richard D. Wood was presented with the Surgeon General's Medallion for his longtime leadership of the hospital. Pictured here are, from left to right, Dr. William Bennett, surgeon; Frank R. Wallace, trustee; C. Everett Koop, MD, US surgeon general; Lucy Rorke, president of the medical staff; Richard Wood, former president of the hospital; and Edmond Notebaert, president and CEO.

OPPOSITE PAGE: The Wood Building opened in 1989. The six-story building housed outpatient subspecialty clinics on the first through fourth floors. The fifth floor held wet-bench laboratory research space, and on the sixth floor were the executive offices and conference rooms.

In 1984, Dr. William Potsic, division chief of otolaryngology, ventured beyond the hospital campus to create an outpatient presence in the suburbs of Philadelphia. He recognized that his surgeons needed to go where the patients lived to provide convenience, comfort, and confidence in the quality of care only the children's hospital could offer. The push came when the Schuylkill Expressway was closed for construction, creating difficulties for patients to get into Philadelphia for office visits. (Courtesy of Dr. William Potsic.)

Under Dr. Potsic's leadership, the division started an office at 583 Shoemaker Road in King of Prussia, Pennsylvania, in May 1984. The otolaryngology division opened this location on its own but was joined by ophthalmology and other surgical divisions several years later. In less than two years, the division was seeing about a third of its patients at this office. Several years later, along with the hospital, the first specialty care and ambulatory surgery centers were opened in Voorhees, New Jersey, and Exton, Pennsylvania, respectively. (Courtesy of Dr. William Potsic.)

The Children's Hospital of Philadelphia's first primary care practice, then known as Kids First, was launched in 1994 with Drs. Bonnie Offit, Kathy Long, Susan Magargee, Francesca Mattone, and Joanne Woehling. The practice later became known as Kids First Haverford. Today, the hospital has 30 primary care practices in two states, generating 700,000 patient visits per year. Pictured here is the CHOP Care Network Chadds Ford Primary Care practice, which opened in 2001. (Courtesy of The Children's Hospital of Philadelphia Public Relations Department.)

In 1994, the first specialty care center opened in Voorhees, New Jersey, and several years later, the first ambulatory surgical center opened in Exton, Pennsylvania. Today, the hospital has 10 centers, generating 364,000 visits throughout the community and on the hospital's main campus. The CHOP Care Network has served as an important strategy for the hospital over the last 20 years and has facilitated access to quality care for the children living in communities surrounding Philadelphia. The Bucks County Specialty Care Center is pictured here. (Courtesy of The Children's Hospital of Philadelphia Public Relations Department.)

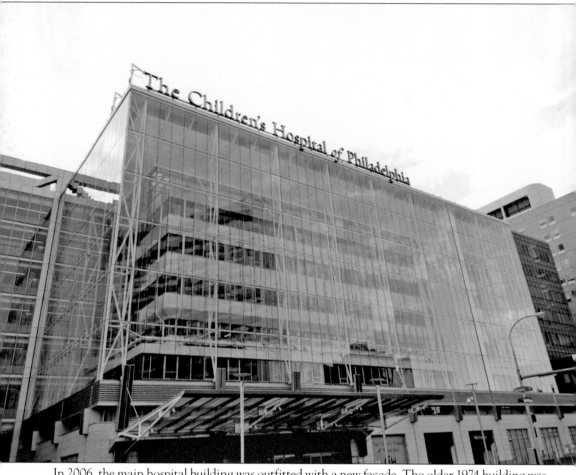

In 2006, the main hospital building was outfitted with a new facade. The older 1974 building was leaking and needed to be modernized. Several new patient towers and a new emergency department have been added since the first building in 1974. The current complex of inpatient buildings houses 535 beds. (Courtesy of The Children's Hospital of Philadelphia Public Relations Department.)

In 1994, Hilary Rodham Clinton, then first lady of the United States, visited the hospital. She was in Philadelphia to discuss her health care reform plan with health care leaders at the University of Pennsylvania and The Children's Hospital of Philadelphia. She toured the hospital with Edmond Notebaert, president and CEO. Notebaert served in these roles for 13 years, from 1987 to 2000; under his leadership, the hospital saw significant growth and a return to financial stability.

CHILDREN'S HOSPITAL,

"DONATION DAY,"

WEDNESDAY, NOVEMBER 18, 1903.

In sending out their circular this year the Ladies' Committee feel compelled to make an urgent appeal to the friends of this Hospital for aid.

For several years past the cost of maintenance of the Hospital and its Branch, notwithstanding the strictest economy in the management, has largely exceeded its income. During the last year the large number of typhoid cases, with the additional nurses required, added to the expense. The price of meats and provisions has risen while bequests and donations have diminished.

Contributions in money are therefore earnestly asked for. Cheques may be drawn to the order of the Children's Hospital, or of Miss F. F. Caldwell, Secretary of the Ladies' Committee.

Donations of all kinds will be thankfully received; especially coal, provisions, groceries, dry goods, blankets, spreads, old linen or muslin, wearing apparel, etc.

The Ladies' Committee will be in attendance at the Hospital (22nd Street, below Walnut) to receive and acknowledge all donations, and to show the Wards to persons interested.

LADIES' VISITING COMMITTEE.

MRS. J. EDGAR THOMPSON, President.
MRS. J. H. HUTCHINSON, Vice-President.
MISS F. F. CALDWELL, Secretary.

MISS BACHE,	MRS. E. S. SAYRES,
MISS E. N. BROWN,	MISS M. W. PAUL,
MRS. W. WEIR,	MRS. JOHN LECONTE,
MRS. A. C. HARRISON,	MRS. S. WARREN INGERSOLL,
MRS. J. CAMPBELL HARRIS,	MRS. I. MINIS HAYS,
MRS. R. L. ASHHURST,	MISS CARRYL,
MRS. RUDULPH ELLIS,	MRS. J. CROSBY BROWN,
MRS. J. M. P. PRICE,	MISS HENRIETTA D. BACHE,
MRS. C. E. DANA,	MRS. J. P. McPHERSON,
MRS. C. B. COXE,	MRS. JOSEPH B. HUTCHINSON.

From its humble beginnings, the hospital has enjoyed philanthropic support from the community. In 1903, the Ladies Visiting Committee launched a campaign to support the operating expenses of both the hospital and its Country Branch. From its founding to the current day, the hospital has benefited from the generosity of others to help expand its research, clinical programs, and buildings.

A year before the hospital opened, the League of Children's Hospital held its annual fundraising event, the Carousel Ball, in the hospital courtyard. The April 1973 ball was attended by 800 hospital supporters. Decorations were handmade and the food was cooked on kerosene stoves since the hospital kitchen had not yet been constructed. Amid the piles of construction rubble, the Philadelphia Mummers strutted down Civic Center Boulevard to welcome the Carousel Ball guests.

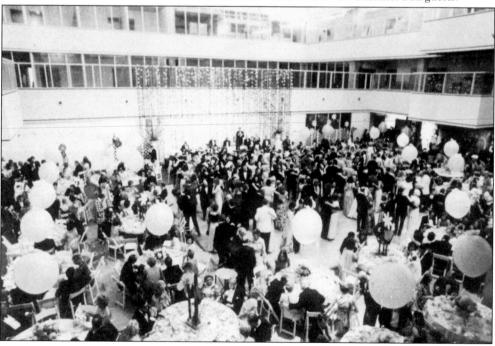

Former Philadelphia mayor Frank Rizzo participates in hospital fundraising by contributing to Daisy Day. He is responding to the appeal from two-year-old Orrie Hicks during the mayor's annual Daisy Day proclamation in 1977.

Daisy Day has been an important part of the hospital fundraising tradition since the early 20th century. When the campaign began, volunteers collected change, sold paper daisies, and hosted a luncheon, all during the month of May. The first-annual luncheon to recognize Daisy Day volunteers was held 58 years ago. In 1968, Jane Shafer, wife of Pennsylvania governor Raymond P. Shafer, crowned Eleanor Cosgriff as queen of Daisy Day. Cosgriff was a student nurse at St. Francis Hospital in Wilmington, Delaware, and was completing her pediatric training at the hospital. The tradition of crowning a Daisy Day queen has long since passed, but the luncheon continues to be one of the most successful fundraising events of the hospital, raising millions of dollars to support hospital clinical programs.

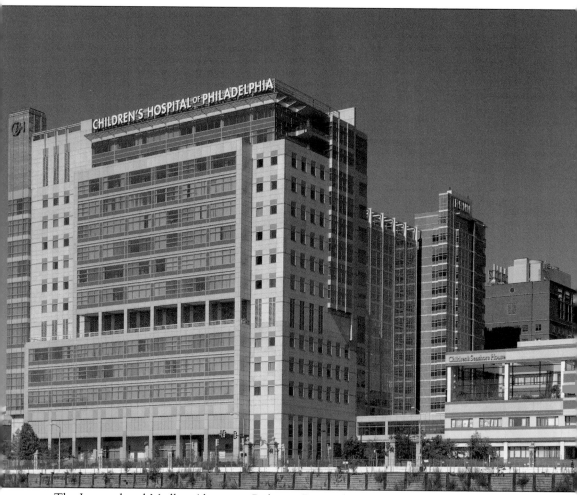

The Leonard and Madlyn Abramson Pediatric Research Center opened in 1995, allowing the research institute to expand into much needed wet-bench research space. The vacated fifth and sixth floors of the Wood Building were expanded to provide additional outpatient clinic space. The Abramson Building led the hospital to recruit top research talent and increase grant funding from the National Institutes of Health and other sources of funding. (Courtesy of The Children's Hospital of Philadelphia Public Relations Department.)

OPPOSITE PAGE: Pictured at the 1995 Abramson Building dedication are, from left to right, Edmond Notebaert, president and CEO; Edward Rendell, mayor of Philadelphia; Tom Ridge, governor of Pennsylvania Leonard Abramson, hospital trustee; Madlyn Abramson; and Richard Armstrong, chairman of the board of trustees. Through the generosity of the Abramson family, millions of children's lives have been enhanced by breakthrough research conducted in this facility. (Courtesy of Paul Crane Photography.)

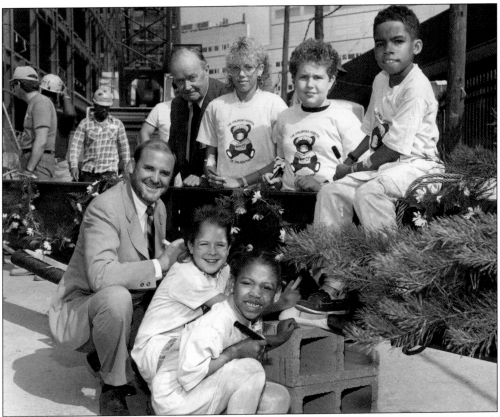

Former president and CEO Edmond Notebaert (kneeling) and chairman Richard Wood pose with patients at the topping-off ceremony for the Abramson Pediatric Research Center in 1993.

A collaborative effort between cardiac surgery, cardiology, cardiac anesthesiology, and cardiac nursing, the Cardiac Center opened on the sixth floor of the hospital in 1994. It includes a dedicated intensive care unit, step-down unit, procedure unit, operating rooms, and imaging department. Pictured with a patient family at the ribbon cutting are, from left to right, Edmond Notebaert, president and CEO; Dr. Thomas Spray, division chief of cardiothoracic surgery; Dr. Victoria Vetter, division chief of cardiology; Dr. Susan Nicolson, division chief of cardiac anesthesiology; and Dr. B.J. Clark. (Courtesy of The Children's Hospital of Philadelphia Public Relations Department.)

Opened in June 2008, the Garbose Family Special Delivery Unit was the first of its kind in the nation, providing specialized delivery and operating rooms for babies with known congenital anomalies. Pictured here at the ribbon cutting are, from left to right, Bill Garbose; Lynne Garbose, hospital trustee; Steve Altschuler, CEO; Dr. N. Scott Adzick, surgeon-in-chief; Felicia and Roberto Rodriguez, former patient; Lori Howell, executive director of the Center for Fetal Diagnosis and Treatment; Susan Amos, former nurse manager; and Dr. Mark Johnson, director of obstetrical services. In addition to providing funding for the special delivery unit, the Garbose family has a long tradition of supporting the hospital. (Courtesy of The Children's Hospital of Philadelphia Public Relations Department.)

With each fetal surgery, images like this can be seen in both the operating room and a remote conference room. These surgeries are observed for teaching purposes by a variety of clinicians in training. (Courtesy of The Children's Hospital of Philadelphia Public Relations Department.)

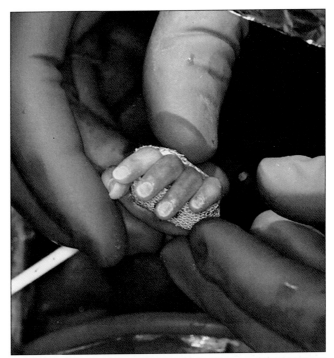

Dr. N. Scott Adzick, surgeon-in-chief since 1995, is seen here preparing for fetal surgery. In addition to the special delivery unit, Dr. Adzick has developed and led the Center for Fetal Diagnosis and Treatment since its founding in 1995. As of June 2014, more than 16,000 mothers have been referred to the center, 10,000 have been evaluated, and more than 1,100 fetal surgeries have been performed. (Courtesy of The Children's Hospital of Philadelphia Public Relations Department.)

Pictured at the beam signing for the Colket Building are, from left to right, Stephen Burke, chair of the board of trustees (2008–2011); Tristram Colket, trustee; Ruth Colket, trustee; Dr. Steven Altschuler, CEO; and Dr. Philip Johnson, executive vice president and chief scientific officer. Tristram and Ruth Colket have a long history of service and philanthropic support to the hospital. Tristram has been a member of the board of trustees since 1969, seeing the hospital through a move and significant expansion. Ruth, a former nurse, has been an active supporter of the hospital's nursing department, as well as a patient safety advocate. (Courtesy of The Children's Hospital of Philadelphia Public Relations Department.)

In 2010, a second state-of-the-art research building was opened. The Ruth and Tristram Colket Translational Research Building, a 730,000-square-foot translational research facility, is the hospital's first LEED (Leadership in Energy and Environmental Design) gold-certified building. (Courtesy of The Children's Hospital of Philadelphia Public Relations Department.)

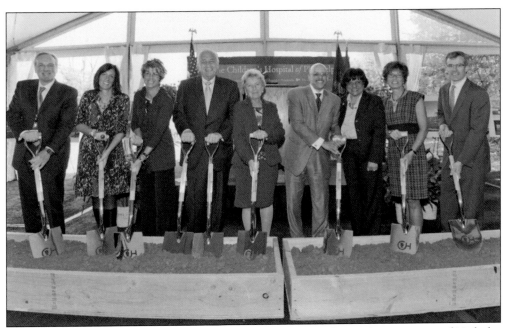

The Karabots Pediatric Care Center opened in January 2013 due to the generosity of Nicholas and Athena Karabots. The center provides primary care, Early Head Start, and community-based programming for the children of West Philadelphia. Pictured at the ground breaking are, from left to right, Steven Altschuler, CEO; Connie Karabots Kolkka, Andrea Karabots Duloc, Nicholas Karabots, and Athena Karabots, donors; Vincent Hughes, Pennsylvania state senator; Jannie Blackwell, city councilwoman; Despina Karabots McNulty, donor; and Mortimer "Tim" Buckley, chairman of the board of trustees. (Courtesy of The Children's Hospital of Philadelphia Public Relations Department.)

Shown at the ribbon cutting for the new Karabots Pediatric Care Center are, from left to right, Steven Altschuler, CEO; Jannie Blackwell, city councilwoman; Athena and Nicholas Karabots, donors; Michael Nutter, mayor of Philadelphia; and Madeline Bell, president and chief operating officer. (Courtesy of The Children's Hospital of Philadelphia Public Relations Department.)

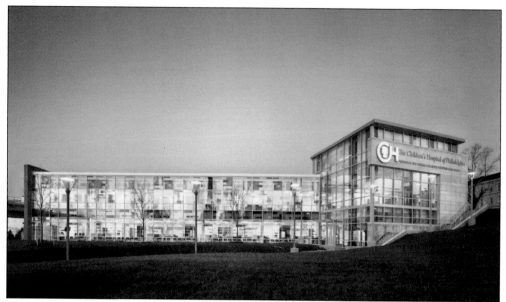

The Karabots Pediatric Care Center, a 52,000-square-foot primary care center located at Forty-eighth and Market Streets in Philadelphia, is pictured here in 2013. (Courtesy of The Children's Hospital of Philadelphia Public Relations Department.)

Pictured here is the interior of the Karabots Care Center. Its natural light and solar panels helped the building to achieve silver LEED certification. (Courtesy of The Children's Hospital of Philadelphia Public Relations Department.)

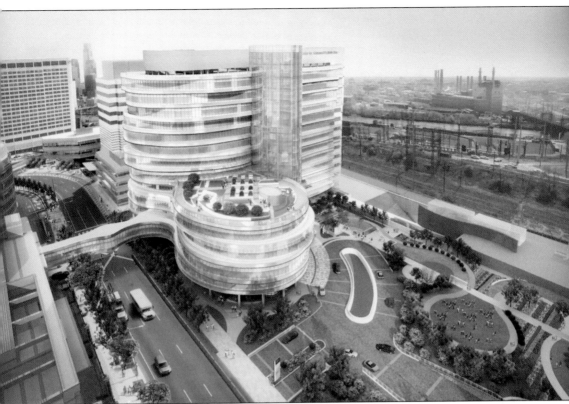

The Buerger Center for Advanced Pediatric Care, seen here in an artist's rendering, is the largest building in the history of the hospital, exceeding 700,000 square feet. Through the generosity of the Buerger family, the center is scheduled to open in the summer of 2015 as a state-of-the-art outpatient destination, including a 2.6-acre landscaped outdoor plaza, 14,000-square-foot roof garden, 1,500-car underground garage, and a garden plaza at street level. (Courtesy of The Children's Hospital of Philadelphia Facilities Department.)

Pictured at the beam signing for the new Buerger Center are, from left to right, Mortimer "Tim" Buckley, chairman of the board of trustees; Alan Buerger, Constance Buerger, Reed Buerger, and Krista Buerger, donors; Steven Altschuler, CEO; and Madeline Bell, president and chief operating officer. (Courtesy of The Children's Hospital of Philadelphia Public Relations Department.)

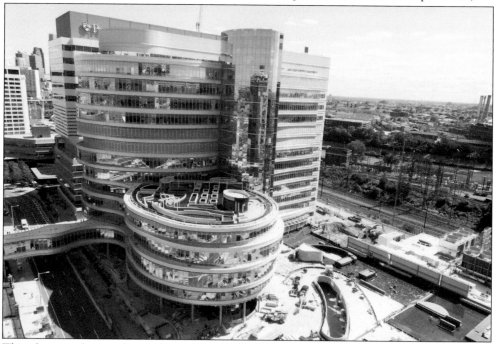

This photograph was taken in September 2014, approximately 10 months before the opening of the Buerger Center for Advanced Pediatric Care on July 27, 2015. (Courtesy of The Children's Hospital of Philadelphia Facilities Department.)

The first three buildings of the hospital have since been demolished. On the site of the former Country Branch stands an apartment building. Once a rural area, it is now a bustling urban neighborhood. Until recently, one remnant of the hospital remained—the archway to the country house, seen here in an overgrown area behind the Wynnefield train station in Philadelphia. With recent storms, the archway was toppled by a large tree. Mark Kocent, architect and the University of Pennsylvania's principal planner, took this photograph while surveying the archway.

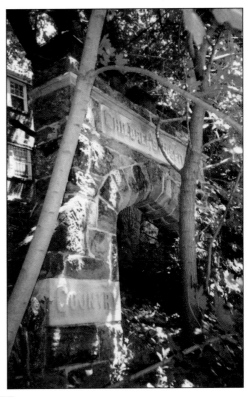

Dr. Steven Altschuler, former CEO of The Children's Hospital of Philadelphia, led the hospital through a time of significant expansion and success from 2000 to 2015. Dr. Altschuler is a gastroenterologist, as well as a former fellow, attending physician division chief, and physician-in-chief of the hospital. Dr. Altschuler led the expansion of the CHOP Care Network, International Medicine program, main campus, and research institute. Under his leadership, clinical and community programming significantly expanded as well. Due to his efforts, the hospital is recognized as the leading children's hospital in the nation. (Courtesy of The Children's Hospital of Philadelphia Public Relations Department.)

Discover Thousands of Local History Books
Featuring Millions of Vintage Images

Arcadia Publishing, the leading local history publisher in the United States, is committed to making history accessible and meaningful through publishing books that celebrate and preserve the heritage of America's people and places.

Find more books like this at
www.arcadiapublishing.com

Search for your hometown history, your old stomping grounds, and even your favorite sports team.

Consistent with our mission to preserve history on a local level, this book was printed in South Carolina on American-made paper and manufactured entirely in the United States. Products carrying the accredited Forest Stewardship Council (FSC) label are printed on 100 percent FSC-certified paper.

MADE IN THE USA